Duane HANSON

PORTRAITS
FROM THE
HEARTLAND

ERIKA DOSS
WESLA HANSON
TIN LY

PLAINS ART MUSEUM
NEW RIVERS PRESS, 2004

Copyright © 2004 Plains Art Museum, Fargo, North Dakota.

All rights reserved. This book may not be reproduced in whole or in part without written permission from the publishers.

First Edition

ISBN: 0-89823-220-1

Library of Congress Control Number: 2003093347

A Many Minnesotas Book

Catalog Creative and Print Management by Pettit Network, Inc., Afton, Minnesota.

Design by Kevin Nyenhuis and Susan Knapp.

Edited by Ann Clark, Kathleen Enz Finken, Judy Foss, and Rusty Freeman

Every effort has been made to locate the copyright holders for the photographs used in this book.
Any omissions will be corrected in subsequent editions.

For academic permission please contact Frederick T. Courtright at 908-537-7559 or permdude@eclipse.net.

For all other permissions contact The Copyright Clearance Center at 978-750-8400 or info@copyright.com

New Rivers Press is a nonprofit literary press and a teaching press associated with Minnesota State University Moorhead.

Plains Art Museum

704 First Avenue North, Fargo, N.D. 58102

www.plainsart.org 701-232-3821

New Rivers Press

c/o Minnesota State University Moorhead

1104 7th Avenue South, Moorhead, MN 56563

www.newriverspress.com 218-477-5870

Printed in China

Front cover: Duane Hanson with *Bowery Derelicts,* 1969.

Back cover: Top: *Self Portrait with Model* (detail), 1979; Tin Ly and Duane Hanson (detail), 1998; *Housepainter* (detail), 1988; *Cowboy* (detail), 1995; Duane Hanson working with Duane Jr. (detail), 1976; Duane Hanson with *Man with Handcart,* (detail), 1978.

Endpapers- front: Duane Hanson talking to University of California at Berkeley students, 1978.

Endpapers- back: Hanson's studio in Davie, Florida with assistant Paul Knebel and *Seated Old Woman Shopper,* 1974. All photographs courtesy of Mrs. Duane Hanson.

Duane HANSON
PORTRAITS FROM THE HEARTLAND

CONTENTS

PRESIDENT'S FOREWORD

We don't simply look at the works by Duane Hanson; we experience them. Viewing his art is not a passive activity. Life size and convincing, his figures exist within a particular social and cultural context. However, at the same time, his work stimulates broader interest by incorporating timeless and universal themes. His sculptures are dimensional; not only in mass, but also in the way they force us to examine and to acknowledge our own apathy when encountering others.

Hanson, a native of Minnesota, developed a strong sense of social justice early in life, which enabled him to empathize with the plight of the "less visible" in society. He questioned our species' ability to turn on itself, and to turn a blind eye. Ironically, we are aware of the presence of his figures in a room, even though we are not looking at them. Concluding that his art was a vehicle that could serve a greater purpose, the artist refused to limit his work to mere exercises in self-expression. Instead, he insisted on confronting the issues of the day as well as calling attention to the mundane daily existence of his fellow human beings. Making art that made a difference was important to him.

The Plains Art Museum is proud to present this exhibition, which celebrates the artist as a social realist. The works are just as relevant today and still have as much impact as they did when first exhibited. In fusing subject matter, content, and intent, Duane Hanson challenged us to be aware and to question the ease in which we selectively perceive our world.

Edward E. Pauley
President/CEO
Plains Art Museum

ACKNOWLEDGMENTS

This project begins with Mrs. Duane (Wesla) Hanson and was realized through her steadfast commitment to it from the beginning. Thank you, Wesla. She made numerous suggestions along the way that improved the quality of the project, and I am especially grateful for Wesla recommending that we pay a visit to Duane's cousin, Charles Ellsworth "Chuck" Carlson, who offered us new insights about his cousin and his relation to his homeland. Tin Ly has been instrumental to the project, assisting with installations and for his insights offered through his interview. Thank you, Tin, for your insights, both personal and professional, in working with Duane. Most of all I would like to thank Erika Doss for her commitment to the project. Erika quickly recognized the importance and scope of the project, and her essay brings every aspect of the exhibition and catalog into focus. For the first time, we understand one of the Midwest's most important artists in a clear relation to his cultural past. Erika's scholarship guided the project to its destination.

The Plains Art Museum staff stepped up in manifold ways with this project. They proved that major accomplishments and scholarly contributions happen in small, out of the way, regional institutions. I am appreciative of the former president/CEO of the museum, Todd D. Smith, for his support of this project. He recognized the capabilities of the museum staff from the beginning. I am especially grateful for Jen Holand, associate curator of programming, for suggesting that we consider "local" artist, Duane Hanson, in the first place. Thanks to Mark Ryan, registrar, for his unfailing professionalism in organizing the massive shipping project and overseeing the deinstallations of the exhibition at the tour cities. A very special thank you to Sandra Ben-Haim, curator of education, for her scholarly research and essay on Hanson. Her important interview with Chuck Carlson and discovery that Duane Hanson is buried in Minnesota shed new light on the artist's relationship to his strong and long-lasting familial roots. Thank you to Anna Goodin, assistant curator of collections and exhibitions, for establishing the first strong contact with Mrs. Hanson and for her excellent contributions to the catalog. My special thanks to Ann Clark, vice president for development and member services, for her editorial prowess, and for her great sense of humor. Thanks to Jill Viehweg, foundation and corporate support manager, for her tireless search for funds. Thank you to Sue Petry, public information manager, for her indefatigable efforts in promoting the exhibition. Thank you to Frank McDaniels, museum technician, for his assistance installing the exhibition. I am especially grateful to Judy Foss, assistant to the president/CEO, for her editorial contributions to the catalog. Thanks to Cody Jacobson, graphic designer, for his design and production of the educational guide. Thank you to Edward Pauley, current president/CEO, for his commitment to the project.

I thank wholeheartedly Wesla Hanson and David Gossoff for loaning their works to the exhibition. I am grateful for the commitment and support of curators and directors at the tour institutions for hosting the exhibition, especially Marsha Gallagher and Ruby Hagerbaumer, Joslyn Art Museum; James Patten, Art Gallery of Windsor; Nanette Maciejunes, Columbus Museum of Art; and John Wetenhall, Ringling Museum of Art.

A special thank you to catalog creative and print management by Bruce Pettit, and designers, Kevin Nyenhuis and Susan Knapp, for creating such a book of dynamic visual appeal that it readily conveys the significance of its contents. A book of this scope, that sought from the beginning a new reading of the artist, could not have been accomplished without the support of our co-publisher, New Rivers Press of the Minnesota State University Moorhead, and its editors Al Davis, Kathleen Enz Finken, and Wayne Gudmundson.

The Plains Art Museum gratefully acknowledges the support of American Express Company, which provided a grant for this exhibition.

Rusty Freeman, Vice President for Collections and Public Programs
Plains Art Museum, May 2003

LENDERS TO THE EXHIBITION

David Gossoff
Mrs. Duane Hanson

EXHIBITION ITINERARY

Plains Art Museum, Fargo, North Dakota | *February 5 - April 11, 2004*
Joslyn Art Museum, Omaha, Nebraska | *May 8 - August 1, 2004*
Art Gallery of Windsor, Canada | *August 27 - November 14, 2004*
Columbus Museum of Art, Columbus, Ohio | *December 10, 2004 - March 6, 2005*
The John and Mable Ringling Museum of Art, Sarasota, Florida | *April 28 - July 31, 2005*

PROJECT TEAM

EXECUTIVE
Edward E. Pauley, President/CEO
Judy Foss, Assistant to the President/CEO

COLLECTIONS AND PUBLIC PROGRAMS
Rusty Freeman, Vice President for Collections and Public Programs
Sandra Ben-Haim, Curator of Education
Jen Holand, Associate Curator of Programming
Anna Goodin, Assistant Curator of Collections and Exhibitions
Pam Jacobson, Assistant Curator of Outreach
Mark Ryan, Registrar
Frank McDaniels, Museum Technician
Mark Franchino, Print Studio Manager

DEVELOPMENT AND MEMBER SERVICES
Ann Clark, Vice President for Development and Member Services
Romelle D. Speral, Major Gifts Manager
Joni Janz Peterson, Membership Manager
Jill Viehweg, Foundation and Corporate Support Manager
Sue Petry, Public Information Manager
Cody Jacobson, Graphic Designer

OPERATIONS
Ben Clapp, CFO/Vice President for Operations

Business
JoAnn Abrahamson, Accountant
Monica Quenzer, Accountant II
Lois Kroke, Accounting Clerk
DeAn Tanous, Accounting Clerk
Elain Helmer, Accounting Clerk

Security/Reception
Steve Beckermann, Operations Manager
Eileen Dustin, Receptionist

Human Resources
Pat Harris, Human Resources Coordinator
Lorine Bernhardt, Human Resources Assistant

Special Events
Kelly Binfet, Special Events Coordinator

Maintenance
Chad Heille, Custodian

Café Muse
Al Arola, Food Service Manager
Chris Nelson, Kitchen Supervisor/Chef
Christopher Gregory, Baker/Prep Cook
Penny Solum, Food and Beverage Supervisor

INTRODUCTION

Duane Hanson was born and reared in Minnesota, yet most people consider him to be from Florida, his adopted home of 27 years. This exhibition and catalog set out to examine in closer detail the cultural connection Hanson had with his homeland. There was a strong suspicion that Hanson's unequivocal recognition of the everyman was firmly grounded in his Midwestern roots. We found it to be true.

This catalog from the outset wanted to find new voices, new perspectives, from which to consider Hanson and his work. We found three: Wesla Hanson, Tin Ly, and Erika Doss. The two newest voices are his wife, Wesla Hanson, and his longest serving assistant, Tin Ly. Both contributed new insights and perspectives to the catalog. Mrs. Hanson—Wesla—thoughtfully assembled a pictorial essay from her extensive photographic archives and wrote captions describing the events. Some of her photographs have never been published before, and all of them offer a behind-the-scenes view of Duane's public life and the artists and dignitaries he knew, as well as a glimpse into Duane and Wesla's family life. Wesla's essay provides a collective portrait of the artist and his family.

Tin Ly worked with Hanson for over 10 years and the two became close friends. Tin's insight both as a practicing artist himself, as well as being Hanson's assistant, provided information and new considerations into the artist's working processes, his selections of subjects, and his own conceptual understanding of his work. Tin has never been interviewed in-depth before and he has added an important new context and dimension to our understanding and appreciation of Hanson's oeuvre.

Art historian Erika Doss examined the artist's Midwestern roots presenting a deeper perspective of his cultural background. A native of Wisconsin, Doss established what it was like to grow up in the Midwest, working broadly from the writings of Sinclair Lewis to articulating the region's wry and pervasive sense of humor. Doss writes, "Hanson's lifelong interests in vernacular, everyday habits and attitudes, in middle- and lower-class peoples and experiences, and especially in a social realist style oriented to the psychic dissonance of the modern human condition, were also kindled in the lonely and fatalistic circumstances of small town Midwestern America." Doss quotes the voice of the artist extensively throughout her essay lending her essay an immediacy, as if Hanson was talking directly to the reader about his art. Of the many sources from which Doss quoted the artist, one of the most important is the unpublished interview from 1989 with Hanson conducted by Liza Kirwin, curator of manuscript archives of American Art Smithsonian. Doss considers Hanson a social realist, an artist she says, "intensely preoccupied with making 'real' the social issues and concerns of his time, from America's racial tensions and legacy of violence in the 1960s to the nation's post-industrial sense of ennui, weariness, disillusionment, and despair." Doss comes to regard Hanson's humanist sensibilities similar to "the gritty and unforgiving realism of Raymond Carver's short stories, Robert Altman's films, and Nan Goldin's photographs." Through her reading of his early socio-political pieces and their relation to his later works, Erika establishes his career as the pursuit of a Midwestern vision of social realism.

Together, these new voices build a chorus of fresh perspectives and insights into one of the Midwest's best artists. The project came full circle through the efforts of Plains Art Museum curator of education, Sandra Ben-Haim. Sandra interviewed Charles Ellsworth "Chuck" Carlson, Hanson's cousin who lives in Brandon, Minnesota. In her interview, which can be found in the exhibition's educational guide, Sandra learned that Hanson returned every summer to Parkers Prairie for the annual family reunion. She also discovered that although Hanson lived in Florida for most of his adult life, where he was recognized with numerous state awards, including election to the Florida Artists Hall of Fame, when his time came, Hanson asked to be buried in his home state of Minnesota. Hanson honored his roots and returned home.

Rusty Freeman
Curator and organizer of the exhibition and catalog

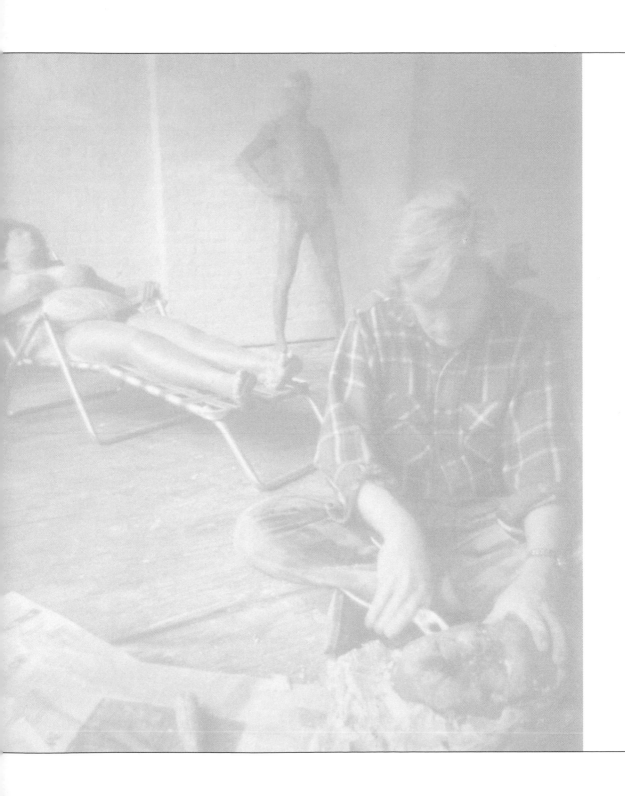

Duane HANSON:
Social Realist from America's Heartland

Erika Doss, University of Colorado

Sinclair Lewis's classic novel *Main Street* opens with these lines:

> This is America—town of a few thousand, in a region of wheat and corn and dairies and little groves.

> The town is, in our tale, called 'Gopher Prairie, Minnesota.' But its Main Street is the continuation of Main Streets everywhere. The story would be the same in Ohio or Montana, in Kansas or Kentucky or Illinois, and not very differently would it be told Up York State or in the Carolina hills. [1]

Published in 1920, Lewis's literary insights about the small minds of small town peoples were loosely based on his upbringing in Sauk Centre, Minnesota, a Midwestern farming community about 130 miles southeast of Fargo, North Dakota, and 110 miles northwest of Minneapolis/St. Paul. Demolishing cherished myths about the sweet, good life in small-town America, Lewis depicted Gopher Prairie as a bigoted and profoundly conservative place that locals blindly insisted was the "best" place on earth. Not surprisingly, Lewis's caustic insights about the mediocrity and meanness of life in America's heartland made him persona non-grata in his hometown, and *Main Street* was even banned for a few years in nearby Alexandria, Minnesota. Still, the novel sold an astounding 180,000 copies by 1921, and in 1930, Lewis became the first American author to win the Nobel Prize. Today, somewhat ironically, Sauk Centre celebrates its notorious native son with an annual "Sinclair Lewis Writers Conference," and a local high-school football team called the "Main Streeters."

This history of *Main Street's* Midwestern controversy and national and international acclaim sets the stage for sculptor Duane Hanson's own history, artistic style, and broad popular appeal; Hanson, after all, was born in Alexandria (in 1925) and grew up well aware of Lewis's reputation in America's heartland. Later in life, Hanson recounted his attempt to visit Lewis's boyhood home only to be told by one Sauk Centre matron, "His books weren't that good." Like Lewis, Hanson was intently engaged in exploring myths about ordinary America and Americans, and in contesting notions of what counts as "good" in American art. Similarly, if his sculptures generated a certain degree of critical indignation—"This we do not consider a work of art," said one journalist about Hanson's early piece *Abortion* (1965), while others dismissed his realistic figures as "merely waxworks"—he became one of the most successful and sought-after contemporary American artists.[2] Importantly, Hanson's lifelong interests in vernacular, everyday habits and attitudes, in middle- and lower-class peoples and experiences, and especially in a social realist style oriented to the psychic dissonance of the modern human condition, were also

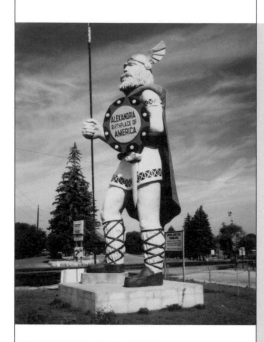

Fig. 1. *Big Ole, the Viking*, Alexandria, Minnesota. 28-foot statue located in Hanson's birthplace.

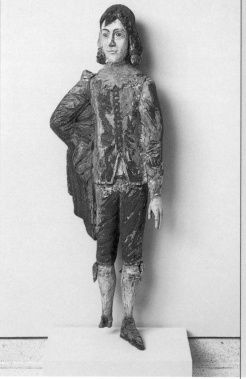

Fig. 2. Duane Hanson, *Blue Boy*, polychromed wood 1938, 47 x 16 x 6 1/2", Collection of Mrs. Duane Hanson.

kindled in the lonely and fatalistic circumstances of small town Midwestern America. "Art on a pedestal is crazy, you know," Hanson remarked in 1989, long after his life-sized polyester and fiberglass sculptures had gained significant art world and popular culture attention, and just a few years before he passed away (in 1996) from cancer. "I don't want to do that. I want to do something that I have strong feelings about, about the society, about war, about the environment, about all these things, which I still have."[3]

Hanson's social consciousness was first nurtured in Alexandria, a small resort town which today features a huge 28-foot statue of "Big Ole," a Viking warrior whose shield bears the legend "Alexandria, Birthplace of America," and whose stance references indefatigable regional claims that America was originally discovered, long before Columbus, in western Minnesota by Scandinavian pirates (Figure 1). In 1930, when Hanson was five, his family moved to Parkers Prairie, a town of about 700 people some 23 miles away. His parents—Agnes Nelson Hanson and Dewey O. Hanson—were second generation Swedes who ran a small 40-acre dairy farm; their only son spent his formative years on the farm and in the town library which, he later recalled, featured only a few volumes on art. One, a book about Roman and Greek sculpture, inspired Hanson to carve "heads of Caesar and whatnots" with his mother's butcher knife. Another, illustrating portraits by 18th-century English artists such as Thomas Gainsborough and Joshua Reynolds, became the source for one of his earliest life-size sculptures, a free-standing version of Gainsborough's well-known painting *Blue Boy* (c. 1770), which Hanson hand-carved from a tree limb and "painted up lifelike" in 1938, at age 13 (Figure 2).[4]

"I was always interested in carving things out, working with my hands, working in three dimensions with clay or wood, plaster, whatever," Hanson recalled, suggesting that his prolific career of object making began in a rural Midwest that respected the old axiom "idle hands are the devil's playground." A curious and active child, if also a sickly one plagued by severe allergies, Hanson kept busy during his Depression-era upbringing by writing poems and short stories, organizing plays at the local high school, and constantly making art. As he noted in 1993:

> I was always experimenting on my own. One time my dad cut down a hollow tree that had a beehive in it. We got the honey out and melted the wax. I stuck my finger in it when it cooled off. Of course, when I pulled the wax off I noticed it sort of made a mold. I then put my whole hand in it and I could slip the whole thing off like a glove and I discovered, not only did it make a mold but I could pour concrete or something in there and every line would come out. Similar to what I do today.[5]

Hanson's art-making energies and interests in experimentation continued into adulthood: Tin Ly, Hanson's assistant in the 1980s and 1990s and the figural model for his sculpture *Chinese Student* (1989), recalled that the artist "was a very hard-working person, a workaholic. He had to be in his studio everyday, even weekends, and he worked past midnight when he would feel like it."[6]

Fashioned from discarded scraps, old broomsticks, and blocks of pine discovered in the farm's woodpile, Hanson's youthful sculptures ranged from works like *Blue Boy* to figurative miniatures and busts of historical personalities such as George Washington, Queen Victoria (Figure 3), and Abraham Lincoln. These early carvings echoed the creative impulses and vernacular craft traditions of generations of New World immigrants, including his Scandinavian forebearers, who spent their occasional free time whittling and

carving both utilitarian and playful objects such as spoons, plates, log chairs, candelabra, toys, dolls, and duck decoys out of found materials (Figure 4). In the 1960s, in fact, Hanson's father and uncle helped him craft some of the elements of his earliest social protest sculptures, including building an old-fashioned wooden coffin for his 1967 piece *Welfare-2598* (Figure 5).[7]

Given his upbringing in rural Minnesota, it's not surprising that Hanson was eventually drawn to making large-scale figurative sculptures as an adult; in 1937, for example, giant roughhewn statues of Paul Bunyan and Babe, the Blue Ox, were erected in Bemidji, a logging town due north of Parkers Prairie. As art historian Karal Ann Marling observes, much of the Midwest is marked by "roadside colossi" of all kinds, including "Hermann the German" in New Ulm, Minnesota, and "Big Ole" the Viking in Alexandria.[8] America's heartland is also marked by a wry regional sense of humor best captured in these seriocomic statues and in Garrison Keillor's "Prairie Home Companion" radio show. That Hanson himself adopted this kind of sardonic Midwestern sensibility is evident in a public talk he gave in 1993, when in a veritable "Lake Woebegone" riff on his own Minnesota hometown, he remarked: "Our town had 720 people. It was very diversified. We had three churches, four gas stations, two grocery stores, a couple of hardware stores, a drug store and a pool hall. One year the pool hall burned down and forty men were left homeless."[9]

Schooled from the start in the creative and imaginative use of ordinary, humble materials, and in the value of work, of making things and keeping busy, Hanson was also interested from an early age in narrative: in telling stories and engaging an audience. Although clearly occupied with the issues and problems of sculptural materials (from clay and wax to wood, stone, polyvinyl, fiberglass, and bronze) and with form-shaping techniques (carving, casting, modeling, and assembling), Hanson's repeated focus on the human figure—from *Blue Boy* to *Man on a Mower* (1995) see page 151, his last completed sculpture—demonstrated a lifelong commitment to an art of social contact and communication. His hyper-real sculptures of ordinary, middle-class Americans, so believable we mumble "excuse me" when we accidentally bump into them in art museums and galleries, were not merely mimetic exercises but consciously crafted social portraits. As Hanson wrote in 1981, "I'm mostly interested in the human form as subject matter and means of expression for my sculpture. What can generate more interest, fascination, beauty, ugliness, joy, shock or contempt than a human being?"[10]

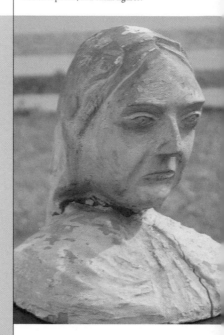

Fig. 3. Duane Hanson, *Bust of Queen Victoria*, c. early 1940s, wood and plaster. Collection of Charles Ellsworth Carlson.

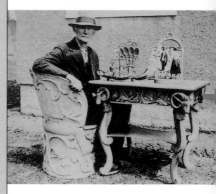

Fig. 4. Minnesota wood carver Tarkjel Landsverk (1859-1948), standing with various examples of his work including a *kubbestol* or log chair, wooden spoons, and small figures.

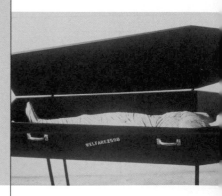

Fig. 5. Duane Hanson, *Welfare - 2598*, 1967, mixed medi Sculpture missing and presumed destroyed.

"Hanson's social consciousness was first nurtured in Alexandria, Minnesota, a small resort town which today features a huge 28-foot statue of "Big Ole," a Viking warrior whose shield bears the legend "Alexandria, Birthplace of America."

Yet art world interests in the human form, and in realist styles, were largely eclipsed in the 1940s and 1950s, when mostly non-objective modes of painting and sculpture held the attention of many critics and museums. Ineligible for military service during World War II because of his allergies, Hanson opted to attend various Midwestern colleges, including Luther (Decorah, Iowa) and Macalester (St. Paul, Minnesota); he also studied art for two years at the University of Washington, where he worked with wood carver Dudley Carter. At Macalester, Hanson got to know Alonzo (Lonnie) Hauser (1909-1988), whose representational sculpture focused on heroic images of ordinary Americans, including a 1939 limestone carving of children and laborers designed for a community building in Greendale, Wisconsin (a "greenbelt" community created by the U.S. Department of Agriculture's Resettlement Administration during the New Deal era), and a 1941 wood relief panel depicting lumberjacks and Indians for a post-office in Park Rapids, Wisconsin.[11] After graduating from Macalester in 1946, Hanson spent a year under the tutelage of University of Minnesota art professor John Rood (1902-1974), a well-known figurative sculptor who in the 1940s worked on a series of hand-carved wooden busts and life-sized torsos depicting average Americans at work and at play, and also national and Midwestern folk heroes such as John Brown, Johnny Appleseed, and Casey Jones.[12] In 1951, Hanson received his MFA from Cranbrook, where he studied with Swedish artist Carl Milles and especially with William McVey (1904-1995), a representational artist who carved and cast statues of George Washington, Winston Churchill, and Jessie Owens for various public parks and embassies, and whose animal sculptures can be found in numerous American zoos.

Influenced by Hauser, Rood, and McVey, Hanson stayed committed to a figurative sculptural tradition throughout his studies. He was also inspired by modern European sculptors such as Auguste Rodin, Aristide Maillol, and Wilhelm Lehmbruck; indeed, he later remarked that Lehmbruck, a realist-expressionist German artist who created emotionally powerful but generally melancholy figures (and who committed suicide in 1919), was his "favorite sculptor as a student."[13] From 1953-1960, Hanson lived in Germany, where he was employed by the U.S. Army Dependent School System to teach art classes in Munich and Bremerhaven to the children of U.S. military servicemen stationed in Europe. Struggling to sustain his interests in narrative and the human form at a moment when abstract art largely dominated, Hanson's early work—which was exhibited at the Galerie Netzel in Worpswede, Germany, in 1958—was generally unremarkable: small in scale, carved from stone, wood, and clay, and half-heartedly attuned to post-World War II non-representational aesthetic styles. "There was no direction," Hanson later recalled. "I hadn't resolved what I wanted to do with sculpture and, as you remember, in the '50s you had Abstract Expressionism and I couldn't latch onto that."[14]

His art gained direction, and began to assume an increasingly realistic tenor, through a chance encounter in 1959 in Bremerhaven with German sculptor George Grygo. Commissioned to build a series of large-scale public sculptures, Grygo was experimenting with cast forms in polyester resin and fiberglass. Intrigued by the malleable, light-weight, and illusionistic possibilities of these new manmade media, in 1963 Hanson applied for and received a $2,000 grant from the Ella Lyman Cabot Trust of Harvard University to fund his own artistic explorations "in the experimental use of synthetic resins and other space-age materials." He had returned to the states in 1960, first

Fig. 6. Duane Hanson, *Abortion*, 1965, wood, plaster, cloth, and mixed media, 16 1/2 x 25 1/2 x 10", Collection of Mrs. Duane Hanson.

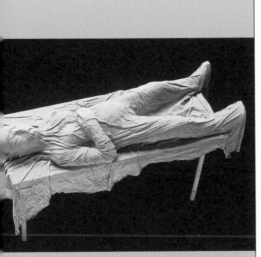

settling and teaching in Atlanta and then, in 1965, moving to Florida, where he taught art classes at Miami Dade Junior College and began working on a series of life-size realist sculptures aimed at "depict[ing] some of the latent and explicit terrors in our social environment."[15]

Abortion (1965, Figure 6) was the first of these, a sobering figure of a dead pregnant woman sprawled on a dirty table covered by a sheet. Distressed by the deaths of a large number of young girls at the hands of illegal and incompetent abortionists in Florida in the mid-1960s, and by subsequent public debates about the morality of reproductive rights, Hanson remarked: "I wanted to make a statement about why our society would force them to risk an illegal operation. Something had to be done to awaken the public."[16] This figurative sculpture certainly did that: selected by juror and well-known assemblage sculptor Richard Stankiewicz as one of 27 works (out of 158 entries) for the annual "Sculptors of Florida" exhibition in 1966, *Abortion* generated an angry firestorm among local art critics, who denounced it as "non-art" because of its "objectionable" subject matter. As *Miami Herald* writer Doris Reno snarled: "We inevitably consider such objects and treatments as outside the categories of art . . . and continue to wish that such works which merely attempt to express experience in the raw could be referred to by some other term."[17] Hanson's colleagues at Miami-Dade Junior College must have concurred, and while he wasn't fired from his teaching job he was forbidden from using the college's studio facilities to produce any further sculptures.

Undeterred, Hanson found a new studio in Opa-Locka, Florida, and went on to produce a large series of social protest pieces. In fact, the controversy over Abortion "sort of lighted a fire under me," he remarked in a 1977 interview with Martin Bush.18 While Abortion was rendered in plaster, wood, and cloth, somewhat akin to the coarse, unpainted plaster sculptures of his contemporary George Segal, in 1967 Hanson began his first figural casts from live models with polyvinyl resins and fiberglass. These included Welfare-2598 (Figure 5), a full-size figure of a gaunt, impoverished man in a rudimentary wooden coffin, buried as a "number," not a name; Gangland Victim, a gruesome depiction of a tortured and decomposed body subjected to mob violence; Trash (see page 102), a dented metal can overflowing with garbage and the smothered body of a newborn child; Motorcycle Accident, a sculpture of a horribly mangled teen-age boy, blood pouring from his mouth, pinned underneath a red scooter; and a group of three equally raw and disturbing figures including a hanged man, a murdered woman, and a girl who had been raped and nailed to a tree by the Outlaws, a Florida motorcycle gang.

Fig. 7a. (Far left) *Policeman and Rioter* photographed on the rooftop of Hanson's Bleecker Street studio in New York City, 1969. Collection of Mick Flick.

Fig. 7b. The complete *Race Riot* installation photographed outside Hanson's Opa-Locka, Florida studio. *Race Riot*, 1968, mixed media, originally 74x 240x 144". (*Race Riot* became *Policeman and Rioter* after five of the figures were accidentally destroyed in a fire.)

Exhibited in various Florida museums, many of these pieces were deemed deeply offensive: indeed, in 1969, 40 artists invited to participate in the "Sculptors of Florida" exhibition withdrew their work in protest of the inclusion of *Trash,* which was notorious not only for its upsetting subject matter but because rotting grapefruit rinds in the garbage can attracted swarms of fruit flies. In 1968, *Gangland Victim* received a Special Merit commendation at the Florida State Fair (as awarded by juror George Segal). But this sculpture and *Motorcycle Accident* were both banned from an exhibition that year at Miami's Bacardi Museum because, as director Alberto Fernandez-Pla explained, "People come here to relax and see some beauty, not to throw up." News of the ban was syndicated nationwide and prompted regional reporters to come to Hanson's defense, including one who wrote: "Like it or not, we live dangerously in a world not very cozy and quite askew. If an artist's choice of subject is not cozy, but disturbing... it is his creative right. Would Bacardi forbid children from attending churches because a tortured image of Christ on a cross usually occupies a place of honor?"[19] Moved to another Miami museum, both sculptures attracted considerable public attention: succeeding, as Hanson had hoped, in "awakening" audiences to an understanding of pressing social problems through realistic, three-dimensional sculpture. Indeed, social realism had now become his preferred style, as he recalled after making *Abortion:*

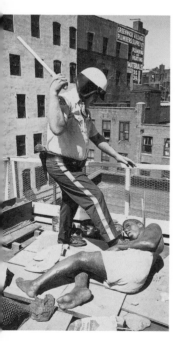
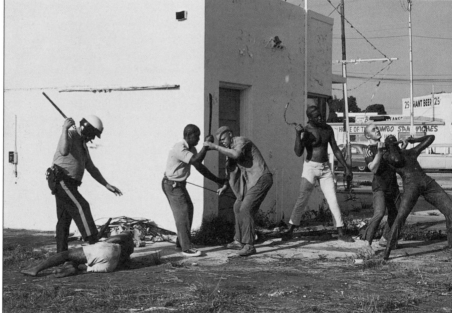

Here at last was something I deeply wanted to say about life around us today. But, more important, after years of uncomfortable ventures into abstract, nonobjective and conventional representative work with the traditional materials of clay, plaster, stone and wood, I had embraced realism as my mode of expression The content or subject matter of my sculpture is derived from my feeling of despair. Realism is best suited to convey the frightening idiosyncrasies of our time.20

Hanson's socially explicit sculptures echoed the sense of social crisis in 1960s America, as the nation confronted deep divides over issues of poverty and violence. He would further address these divides in sculptures such as *Race Riot* and *Pietà* (both 1968), and *War* (1967), all of which alluded to the central ethical dilemmas of the decade: struggles for civil rights and protests against the highly unpopular Vietnam War. *Race Riot* (Figure 7b) was a seven-person scene of a white policeman and several other white men brutally assaulting a group of black men; *Pietà* (Figure 8) featured a young white woman cradling the body of a dead black man in her lap. Similar to Andy Warhol's earlier silkscreens (1963-64) based on photographs of white policemen clubbing peaceful demonstrators in Birmingham, Alabama, as well as contemporaneous protest paintings and prints by David Hammons, Benny Andrews, Betye Saar, May Stevens, and Faith Ringgold (Figure 9), Hanson's sculptures highlighted issues of racial identity and injustice in late 1960s America. Both *Race Riot* and *Pietà* were included in the exhibition *Human Concern/Personal Torment: The Grotesque in American Art,* held at the Whitney Museum of American Art in 1969. As curator Richard Doty wrote, "Civil strife has become a part of art, as well as life, in America. Duane Hanson employs the verisimilitude of the tableau to present the ugly brutality of the hatred between black and white.... So long as violence continues to be a facet of contemporary life, it will also be a significant subject for the artist." Others agreed: John Canaday's review of the Whitney exhibit for *The New York Times* featured a reproduction of *Race Riot,* and *Newsweek* art critic David Shirey singled out the same sculpture as "one of the best works in the show."[21]

Hanson's *War* (Figure 10), a scene of five bloody U.S. infantrymen, four dead and one horribly wounded, their bodies strewn over a muddy, shell-blasted field, is one of the strongest refutations of the Vietnam conflict to appear in 1960s American art. "Its purpose," said Hanson, "is to call attention to war, the grubbiness, the mud, the blood and gore and fatigue, the futility of it all. It's frightening, but it has a message."[22] Working on the sculpture for over eight months, honing the technical problems of casting fiberglass, reinforced polyester resin forms from student volunteers in his Miami Dade classes, shaping and assembling these multiple body casts, painting them in flesh-tones, and then outfitting them in authentic army uniforms, dog tags, and other military regalia, Hanson considered *War* his first "really successful" work. He measured its success on both technical and persuasive terms: "To be successful," he later remarked, "suggests having some sort of impact."[23] Shown at New York's O.K. Harris Gallery in 1970, a well-known space run by Ivan Karp (who became Hanson's major dealer in 1969, when he moved to New York), *War* received considerable press and critical attention and established Hanson's reputation as a leading American social realist sculptor. Along with 1960s works by Peter Saul, H.C. Westermann, James Rosenquist, Red Grooms, Claes Oldenburg, and especially Edward Kienholz, Hanson's *War* clearly "delineated the stalemating of the American dream."[24]

Asked in 1977 if he was "embittered by the Vietnam war or by life," Hanson replied that he was "not embittered, just very critical." He added: "I was just tired of doing high art stuff. I enjoy nice abstract paintings with beautiful color and all that. [But] it was no longer enough. I had to communicate."[25] His shift to polyester resins and fiberglass helped him animate this new social

Although his work shifted in the early 1970s from large-scale installations of blatant social protest to a more circumspect analysis of the human condition in the later decades of the 20th-century, Hanson remained a social realist: a sculptor intensely preoccupied with making "real" the social issues and concerns of his time, from America's racial tensions and legacy of violence in the 1960s to the nation's post-industrial sense of ennui, weariness, disillusionment, and despair.

Fig. 8. Duane Hanson, *Pietà*, 1968, Destroyed.

Fig. 9. Faith Ringgold, *The Flag is Bleeding*, 1967, oil on canvas, 72 x 96", Private collection.

Fig. 10. Duane Hanson, *War*, 1967, Wilhelm Lehmbruck Museum, Duisburg, Germany.

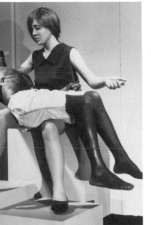
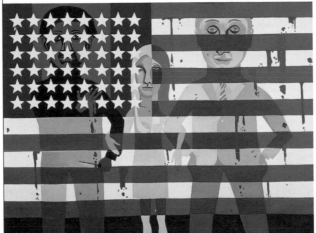
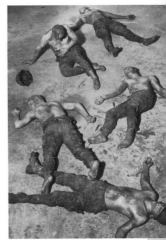

realist work. Somewhat ironically, these manmade, synthetic materials were much closer to the look and feel of the human body, and especially the translucence of human skin. They were also the preferred materials of modern commercial sculptures—such as mannequins—which were similarly attuned to the hyper-real aesthetic that Hanson was adopting. Aiming to "awaken" his audience to his newfound social consciousness, Hanson appropriated the look and style of everyday popular and commercial culture. In his view, traditional art world materials such as marble, limestone, bronze, and clay simply could not approximate the realities of the contemporary human condition.

If synthetic materials provided Hanson with new sculptural directions, it was Pop Art that particularly informed his social realist vision. Absent from America during much of the 1950s, a decade when the GNP expanded 25 percent and the U.S. birthrate boomed (increasing by nearly 50 percent), when more than 85 percent of new houses were built in suburbs—and most of them featured television (by 1960, nearly 90 percent of U.S. families owned at least one TV set), Hanson missed directly experiencing the nation's astounding postwar economic, social, and cultural growth.[26] By the time he returned to the U.S. in 1960, the country he had left still struggling with the aftermath of the Great Depression and World War II had become a global economic powerhouse with a national identity especially attuned to mass consumerism and mass culture. A number of postwar artists, among them Neo-Dada painters and sculptors Jasper Johns and Robert Rauschenberg, and Beat and Funk artists such as Bruce Conner, Jay DeFeo, and Robert Arneson, addressed and problematized the nation's obsessive and conspicuous affluence in the 1950s. In the 1960s, artists aligned with the multifaceted style of Pop similarly appraised and critiqued American culture, raising questions and casting doubts about the inconsistencies and failed promises of the American dream.[27]

"Pop Art was a great influence on my sculpture because realistic imagery was legitimate again," Hanson noted in 1977. "Pop Art made use of common, everyday subject matter in our environment, and I thought it was important. It certainly spurred me on."[28] Pop Art's attention

to generic, anonymous American types—from the comic-book characters of Roy Lichtenstein's canvases and the California suburbanites depicted in Robert Bechtle's deadpan Photorealist paintings, to the alienated Mr. and Mrs. John Does frozen in George Segal's plaster sculpture installations—certainly shaped Hanson's own absorption with ordinary American people and circumstances in the 1960s, and later. "What's more interesting than the people?" Hanson remarked in a 1989 interview. "So I got to doing that. First, it was expressionist, sociological themes, sociological terrors of the '60s. Then that was transformed to satirical types like the tourists and over-stuffed supermarket shopping lady, the sun bather, tough-looking hard hat."[29]

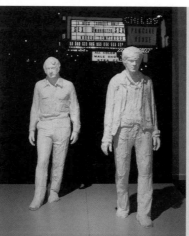

Fig. 11. Duane Hanson, *Janitor*, 1973, polyester, fiberglass, mixed media, 65 1/2 x 28 x 22", Milwaukee Art Museum.
Fig. 12. George Segal, *Times Square at Night*, 1970, mixed media, Joslyn Art Museum, Omaha, Nebraska.

Fig. 13. Edward Kienholz, *John Doe*, 1959, oil paint on mannequin parts, child's perambulator, toy, wood, metal, plaster, and rubber, The Menil Collection, Houston.

Living in New York from 1969-1972, working in a Bleecker Street studio next to a Catholic church that served meals to the indigent, Hanson continued to explore social subjects such as poverty and addiction in large-scale installations such as *Bowery Derelicts* (1969-1970) see page 39, a scene of three homeless men dozing in an alcoholic stupor on a sidewalk littered with trash. "I would look out the window and see them, they would get soaked in alcohol during the day and lie around the sidewalk in front of our doorway," Hanson explained later. "It's shocking to be confronted by these people living in the streets ... I had to do something." His indictment of social suffering in America's "Great Society" led *TIME* magazine art critic Robert Hughes to pronounce *Bowery Derelicts* "one of the most grossly truthful pieces of social observation in American art."[30] Over the next few years, Hanson reduced his social panoramas to single subjects with titles such as *Housewife* (1970), *Hard Hat* (1970), *Tourists* (1970) see [age 55, *Woman Eating* (1971), *Businessman* (1971), *Woman Cleaning Rug* (1971), and *Janitor* (1973, Figure 11). "I discovered that you don't have to hit the viewer over the head every time," Hanson remarked in 1984. "You can come in rather sneaky or underhanded and get the message across."[31]

Although his work shifted in the early 1970s from large-scale installations of blatant social protest to a more circumspect analysis of the human condition in the later decades of the 20th-century, Hanson remained a social realist: a sculptor intensely preoccupied with making "real" the social issues and concerns of his time, from America's racial tensions and legacy of

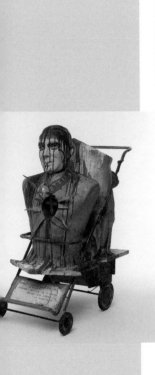

violence in the 1960s to the nation's post-industrial sense of ennui, weariness, disillusionment, and despair. Reflecting on his 1971 sculpture *Seated Artist*, modeled by his friend the painter Mike Bakaty and exhibited at the international art exhibition *Documenta 5* in Kassel, Germany, in 1972, Hanson noted that "there was a sort of sadness about it, as all my work has because I think we're in tough times. I mean the world is not getting any better."[32]

Focused on the quiet, rarely considered lives of undervalued and often disenfranchised middle- and lower-class Americans—janitors, artists, and especially older men and women—Hanson's sculpture became increasingly empathetic and emotionally charged in the 1970s and 1980s. "My work deals with people who lead lives of quiet desperation," Hanson remarked in 1985, echoing a favorite quote by American writer Henry David Thoreau. "People, workers, the elderly, all these people I see with sympathy and affection. These are the people who have fought the battle of life and who now and then show the hard work and the frustration. The clothes they wear describe the life they lead. There is grubbiness and sweat, and there are old people with lines on their faces and the wrinkles. It's all about human activity, it's truth, and we all get there."[33] Contextualized in the last few decades of the 20th century, Hanson's humanist sensibilities are less aligned with Photorealism—a slickly literalist style of painting and sculpture pursued in the 1970s by artists such as Richard Estes, Audrey Flack, Robert Cottingham, Joseph Raffael, and Malcolm Morley— than with the gritty and unforgiving realism of Raymond Carver's short stories, Robert Altman's films, and Nan Goldin's photographs.

While indebted to Pop Art's critically engaged attention to contemporary American themes and subjects, the empathetic sensibility of Hanson's social realist sculptures differed as well from the social surrealism of Segal and Kienholz; indeed, as curator Tilman Osterwold noted in a 1974 retrospective of his work in Stuttgart: "Segal's mummies are opened by Hanson, as it were, Kienholz's surrealistic alienation and hyperbole are brought back to a normal bourgeois measure of reality." (Figures 12 & 13). Likewise, while Hanson and John DeAndrea similarly worked with polyester resins and synthetic materials, DeAndrea's focus on young, idealized female nudes suggested his primary interests in technical perfection and in updating classical figurative sculptural traditions (Figure 14). "I think I'm different from Photorealists and a wonderful artist like John DeAndrea, who does very classical, hyper realistic, beautiful nude figures," Hanson remarked in 1989. "We use similar materials, but he's into a rather aesthetic statement of a beautiful bodied person and... I'm interested in... truth."[34]

Hanson's "truth" was especially oriented to a critical consideration of the nature and meaning of craftsmanship, and of stereotypes. While his sculptures were painstakingly crafted they denied all signs of artistic presence and intervention, thereby subtly subverting distinctions between reality and "reality interpreted." Unlike the Photorealists and DeAndrea, Hanson was neither interested in verisimilitude nor beauty but in engaging viewers in an empathetic gaze, in "awakening" audiences to looking, and looking carefully, at signs of social reality. "The human form is so close to all of us," he observed, "and we don't really get a chance to analyze it, to look at it because of taboos [such as] staring at people."[35] Hanson's visual hook was to tempt us to stare at such convincingly human figures that we are then moved to contemplate the terms of human existence.

Of course, however "realistic" his figures seem to be, Hanson's sculptures were completely and carefully constructed. He began by posing and photographing his models, and then selecting those images which best embodied the typical physical labors and activities of his chosen subjects. Importantly, Hanson chose only the static poses of resting or stopped figures caught in moments of quiet introspection and physical exhaustion, their blank facial expressions contributing, noted curator Keith Hartley, to the "general melancholy air" of his art.[36] Next, after making direct casts of his models, Hanson carefully orchestrated their assembly, coloring, and costuming, always striving for a degree of authenticity that would entice and more importantly, engage his viewers. Even after his sculptures were purchased and displayed in various museums, Hanson took an active role in maintaining their clothing and accessories. In the early 1990s, for example, his 1971 figure *Sunbather* was reinstalled at the Wadsworth Athenaeum with a new bathing suit and sunglasses, and with its original can of Tab and copy of *Day Time TV* substituted with a Diet Coke and a current issue of *Soap Opera*.[37]

Flea Market Lady (1990) embodies Hanson's keen attention to carefully posing and outfitting his figures with what he determined were the "correct" clothes and props. Modeled by his friend Donna Maddox, Hanson's vendor is engrossed in a magazine (a 1985 issue of *Sky*, opened to an article about Hanson himself), wearing a blue T-shirt advertising Florida tourism with the phrase "I am a Big Deal," and surrounded by various examples of "low" art like paint-by-number landscapes. A humorous riff on Maddox—who was an art professor at Columbus State University (Georgia)—*Flea Market Lady* also conveys Hanson's sly assessment of the contemporary art world. As he noted in 1993, "I went to the flea market where I picked out the worst looking examples of art I could find. I thought wouldn't it be wonderful if someday this goes into a very fancy, snobbish museum or gallery."[38]

Such remarks suggest Hanson's abiding interests not in art styles and trends but in social communication. If he carefully sculpted his *trompe l'oeil* figures to lead viewers to question and consider issues of realism, he also carefully selected subjects which encouraged audiences to consider the problems of typecasting and social bias. Rarely naming his characters (one exception is *Queenie II*, 1988), Hanson tended to represent the bodies and labors of anonymous but immediately recognizable American types: *Old Lady in Folding Chair* (1976) see page 104, *Housepainter* (1984) see page 113, *High School Student* (1990) see page 122, *Car Dealer* (1992) see page 128, *Policeman* (1992) see page 138. His scrutiny of these ordinary Americans stemmed from a recognition of how a supposedly class-less nation insists on classifications of race, gender, ethnicity—and class—and makes broad, biased assumptions on the basis of these generalized stereotypes. As critic Peter Schjeldahl remarks, "Encountering Hansons in a museum, one is perforce aware of one's part in the permanent drama of social caste. In the company of fellow-members of a lucky class, I stroll amid likenesses of dramatically less privileged citizens."[39]

Hanson's familiar yet completely fabricated figures were aimed at upsetting and overturning these naturalized American stereotypes by convincing viewers, instead, of their inherent individuality and humanity. While some figures were clearly satirical—Hanson remarked that "he was a little critical" of the "over-consuming housewife" he depicted in *Supermarket Shopper* (1970)—most were empathetic and even heroizing documents of usually overlooked and under considered American types. As he remarked in 1989, there are:

Fig. 14. John DeAndrea, *Linda*, 1983, oil paint on polyvinyl with natural hair, 24 x 24 x 70", Denver Art Museum Collection.

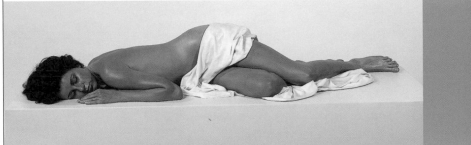

> So many people in our society we take for granted that really hold the fabric of the country together. People in the Army. They sit around for years and all of a sudden they have to go fight.... Even a girl or a lady who works in an office downtown and has to buck all that traffic, has to feed her kids in the morning and go to work and sit there in that traffic ... I think that takes a great deal of stamina to really exist in our society. There are so many types like that. It's not always these people on TV that do outrageous things and get known for it.[40]

Hanson's fixed regard for the often unspoken social realities of middle-class Americana helps account for his great popularity as a contemporary artist. Indeed, record crowds—some 297,000 people—turned out for the Whitney Museum of American Art's retrospective of his work in 1978, setting an attendance record for the museum. Similar numbers flocked to a Hanson retrospective at the same museum in 1998-99. Hanson himself downplayed his broad appeal, saying only "I think it's just that people enjoy seeing a reflection of their society."[41] Despite such self-deprecating commentary—the wry, subtle remarks of an artist reared in the Midwest—the emotional strength of his social realist vision remains Hanson's important contribution to contemporary American art. It comes as no surprise that Hanson is buried in America's heartland too, next to his grandparents in open Minnesota farmland, at a site about 10 miles southeast of Parkers Prairie, near a little hamlet called Spruce Center.[42] ∎

[1] Sinclair Lewis, *Main Street* (New York: Harcourt, Brace & World, Inc., 1920), p. 1.

[2] Duane Hanson quoted in "Interview with Duane Hanson for the Archives of American Art," by Liza Kirwin, Davie, Florida, August 23, 1989. Unpublished manuscript in the Archives of American Art, Smithsonian Institution, Washington, D.C., p. 2. Hereafter referred to as "Kirwin Interview." On criticism of Hanson's early work see Doris Reno, "Taste Marks Sculptors of Florida Annual," *Miami Herald* (October 30, 1966), p. 10-B.

[3] "Kirwin Interview," pp. 2, 44.

[4] Hanson discussed his youthful sculptures in his lecture "Art in the Real World," delivered at the National Art Education Association annual convention, April 1-5, 1993, in Chicago; see Larry Peeno, et.al., Keynote Addresses, NAEA Convention 1993 (Reston, VA: The National Art Education Association, 1993), p. 18; see also "Kirwin Interview," pp. 61.

[5] "Kirwin Interview," p. 8; Hanson, "Art in the Real World," p. 18.

[6] See Colleen Dougher Telcik's newspaper article "Extraordinary Man" at http://www.xs0.com/news/morgue/hanson.htm. See also in this catalog *Interview with Tin Ly, Duane Hanson's Long-Time Assistant*, page 85.

[7] Marion J. Nelson, "Folk Art in Minnesota and the Case of the Norwegian-American," *Circles of Tradition: Folk Arts in Minnesota* (Minneapolis: University of Minnesota Art Museum, 1989), pp. 24-44; on *Welfare-2598* see Thomas Buchsteiner, "Art is Life, and Life is Realistic," Thomas Buchsteiner and Otto Letze, eds., *Duane Hanson: More Than Reality* (Ostfildern-Ruit: Hatje Cantz Publishers, 2001), p. 73.

[8] Karal Ann Marling, *The Colossus of Roads: Myth and Symbol Along the American Highway* (Minneapolis: University of Minnesota Press, 1984), p. 117 and passim.

[9] Hanson, "Art in the Real World," p. 18.

[10] As noted in Hanson's personal copy of Martin H. Bush, *Duane Hanson* (Wichita, Kansas: Edwin A. Ulrich Museum of Art, 1976), collection of Wesla Hanson.

[11] On Hauser see Diane M. Buck and Virginia A. Palmer, *Outdoor Sculpture in Milwaukee: A Cultural and Historical Guidebook* (Madison, Wisconsin: The State Historical Society of Wisconsin, 1995), pp. 115-117, and Barbara Melosh, *Engendering Culture: Manhood and Womanhood in New Deal Public Art and Theater* (Washington, D.C.: Smithsonian Institution Press, 1991), p. 246.

[12] Charles C. Eldredge, "John Rood: The Metamorphosis of a Sculptor," *Works by John Rood: A Memorial Exhibition* (Minneapolis: University Gallery/University of Minnesota, 1974), n.p.

[13] Hanson, "Art in the Real World," p. 22.

[14] "Kirwin Interview," pp. 21-22.

[15] Noted in Laurence Pamer, "Duane Hanson: Early Work," *Duane Hanson: A Survey of His Work from the '30s to the '90s* (Fort Lauderdale, FL: Museum of Art, Fort Lauderdale, 1998), p. 9. Hanson quoted in "Presenting Duane Hanson," *Art in America* (September-October 1970), p. 86.

[16] Martin Bush, *Sculptures by Duane Hanson* (Wichita, Kansas: Edwin A. Ulrich Museum of Art, 1985), p. 31.

[17] Reno, "Taste Marks Sculptors," p. 10-B.

[18] Hanson quoted in "Martin Bush Interviews Duane Hanson," *Art International* (September-October 1977), p. 11. In 1976, Bush organized the first full-scale exhibition of Hanson's works in the United States at the Edwin A. Ulrich Museum of Art in Wichita, Kansas, which then traveled to nine other museums including the Whitney Museum of American Art in 1978.

[19] Tim Buckney, "Museum Bars Sculptures Because They're Too Gory," *Miami Beach Sunday Sun and Independent* (February 3, 1968); Boris Paul, "The Freedom of Art Battles Censorship," *Sunday Sun and Independent* (June 23, 1968); as noted in Bush, *Duane Hanson*, pp. 26, 31-32, 105.

[20] "Presenting Duane Hanson," p. 86.

[21] Richard Doty, *Human Concern/Personal Torment: The Grotesque in American Art* (New York: Whitney Museum of American Art, 1969), n.p.; John Canaday, "Then and Now and Blood and Catsup," *The New York Times* (October 26, 1969), p. 23; David Shirey, "Horror Show," *Newsweek* (November 3, 1969), p. 107.

[22] Bush, *Duane Hanson*, p. 15.

[23] "Martin Bush Interviews Duane Hanson," p. 11.

[24] Sidra Stich, *Made in U.S.A.: An Americanization in Modern Art, The '50s & '60s* (Berkeley: University Art Museum, University of California Press, 1987), p. 203. For a survey of protest art made during and after the Vietnam War see Lucy Lippard, *A Different War: Vietnam in Art*, exh. cat. (Seattle: Real Comjet Press, 1990).

[25] "Martin Bush Interviews Duane Hanson," p. 10.

[32] "Kirwin Interview," p. 47.

[33] Bush, *Sculptures by Duane Hanson*, p. 15, and Ellen Edwards, "Duane Hanson's Blue Collar Society," *ARTnews* (April 1978), p. 60.

[34] Tilman Osterwold, *Duane Hanson* (Stuttgart, West Germany: Württembergischer Kunstverein, 1974), p. 11; "Kirwin Interview," pp. 51-52.

[35] "Kirwin Interview," p. 70.

[36] Keith Hartley, "The Human Figure in Duane Hanson's Art," *Duane Hanson: More Than Reality*, p. 82.

[37] Kimberly Davenport, "Impossible Liberties: Contemporary Artists on the Life of Their Work Over Time," *Art Journal*, vol. 54, no. 2 (Summer 1995), pp. 40-42.

[38] Hanson, "Art in the Real World," p. 22.

[39] Peter Schjeldahl, "Stilled Lives," *The New Yorker* (January 11, 1999), p. 91.

[40] "Martin Bush Interviews Duane Hanson," pp. 13-14; "Kirwin Interview," p. 72.

[41] "Kirwin Interview," p. 69.

[42] Thanks to Sandra Ben-Haim, Curator of Education, Plains Art Museum, for this information; see Sandra Ben-Haim, personal interview with Charles Ellsworth Carlson (cousin of Duane Hanson), April 1, 2003, in *Duane Hanson: Portraits from the Heartland Educational Guide*, (Fargo, North Dakota: Plains Art Museum, 2003).

INTIMATE PORTRAITS:
Friends and Family in the Life of Duane Hanson

Wesla Hanson

Wesla Hanson, Duane Hanson's widow, has perhaps the definitive collection of Hanson books, exhibition catalogs, photographs, materials, and archival records in the world, and of course, the best collection of family records and photographs documenting the artist and his family. Mrs. Hanson has thoughtfully selected 54 photographs creating an intimate journey into her and Duane's family and his career. By sharing her personal memories and photographs, Mrs. Hanson has brought a new perspective that has been neither seen nor heard from before; indeed, some of these photographs have never been published until now.

Intimates Portraits begins in Parkers Prairie, Minnesota, Duane's hometown, with a 1930 photograph of five-year-old Duane. The essay creates a collective portrait of the personal and public sides of Duane Hanson's career—from favorite photographs from the family album to the memorable events of meeting and showing his art to such people as King Carl Gustaf XVI of Sweden, Joan Mondale, and Andy Warhol. It is an appealing portrait of the artist who had met world leaders and knew art world superstars, while creating a legacy that recognized the everyman and woman.

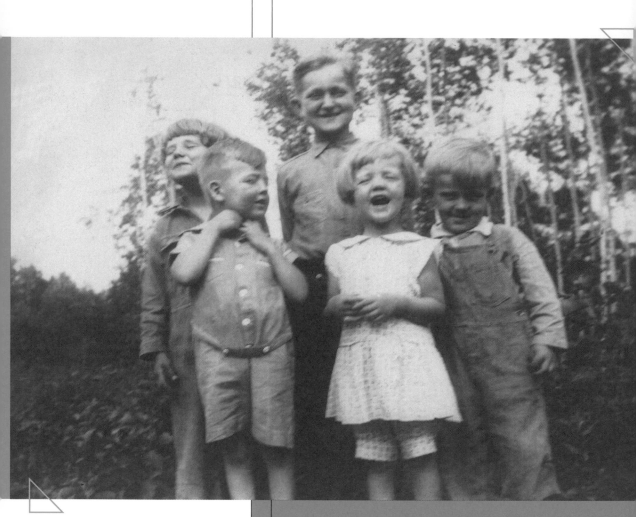

1 Growing up on the farm in Parkers Prairie, Minnesota, with four of his 25 first cousins. Duane in the front on the left (1930).

2 The artist at his exhibition in Worpswede, Germany, with early works. Duane was always interested in the human figure, as can be seen in these sculptures (1958).

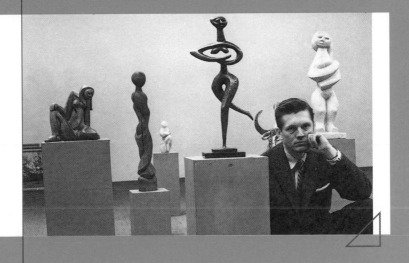

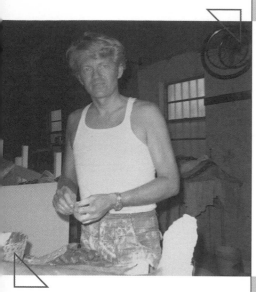

3 Early photo of Duane in his first studio in Opa-Locka, after he moved to Florida from Atlanta. He was teaching art at Miami-Dade Junior College at the time, and they had thrown him out of his campus studio because his work was considered too controversial (1968).

4 The brooding artist poses with *Bowery Derelicts* at O. K. Harris Works of Art in New York City. Duane had modeled for two of the three figures. We had just arrived in New York from the hinterlands of Florida (1969).

5 Works in progress in the loft at 17 Bleecker. Our living space was in the back, and the studio space in the front by the big windows. It was illegal to live in lofts at that time, so we had no heat or elevator after 5 p.m. and weekends. We lived there from 1969-1972 (1971).

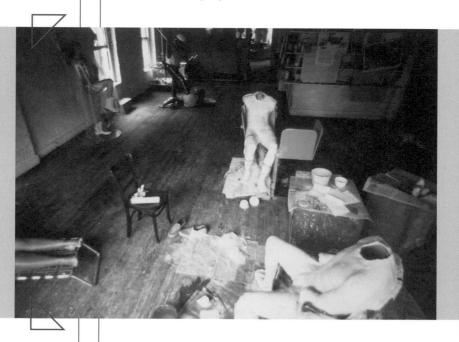

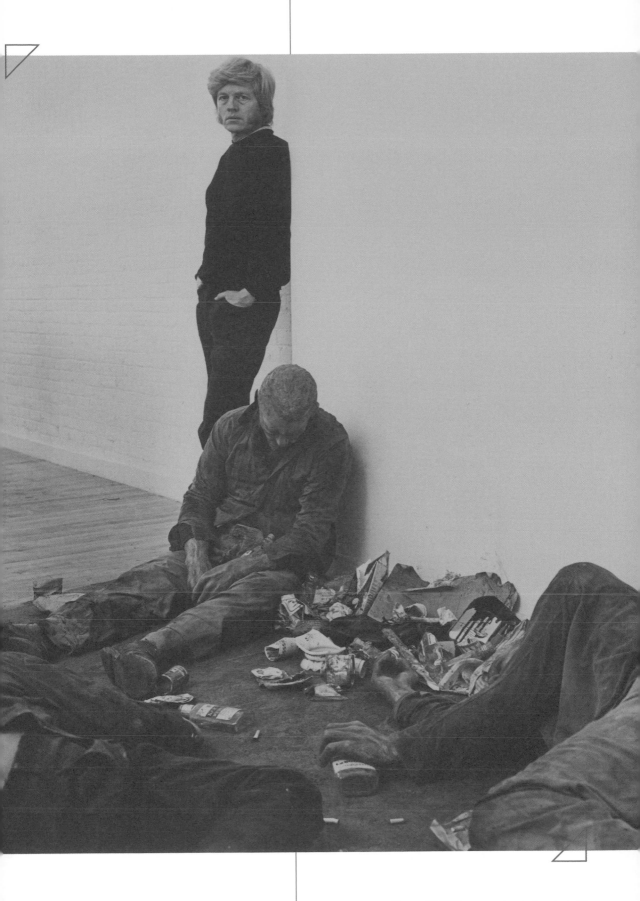

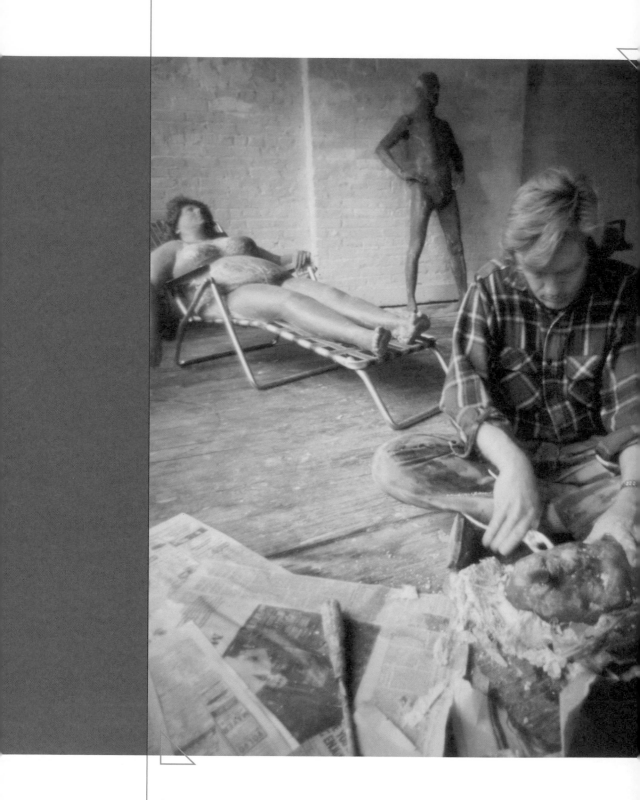

6 Duane working in our loft at 17 Bleecker Street in New York City.
Two unfinished bondo pieces are in the background (1971).

7 Early days in New York in the loft at 17 Bleecker (1972).

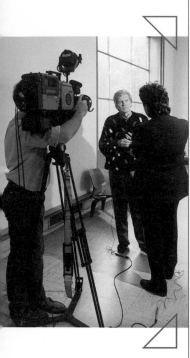

8 Television interview for an exhibition at Cranbrook Academy of Art, Bloomfield Hills, Michigan, where Duane attended graduate school (1973).

9 A favorite family photo, I'm holding Maja and Duane is holding Duane, Jr. (1973).

10 *Man in Chair with Beer,* or part of him, sits in his chair in Duane's garage. When we first bought the house, the two-car garage was used as a studio (1973).

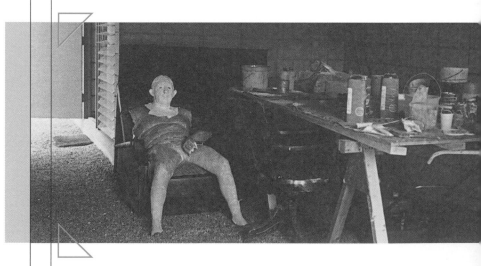

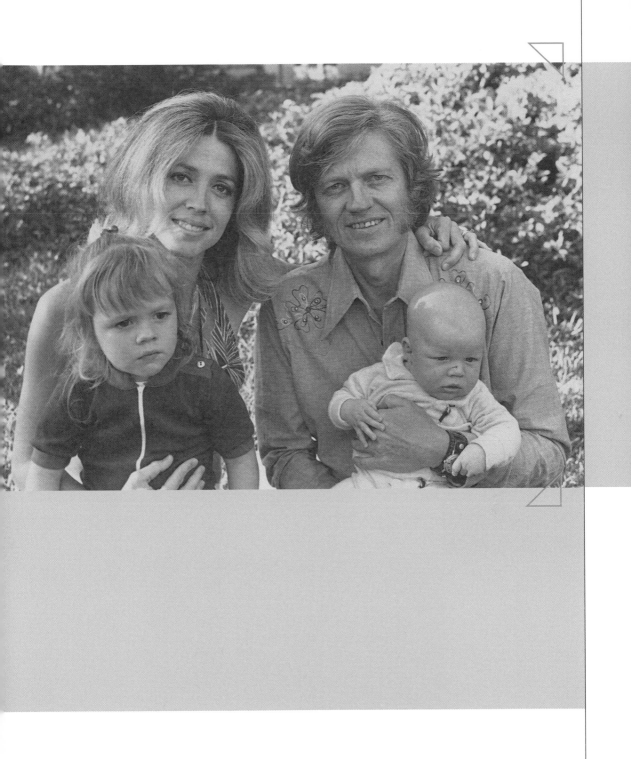

11 (Right) With daughter, Maja, in Davie, Florida (1973).

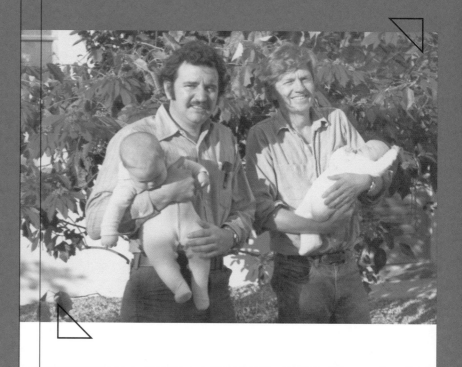

12 Duane and good friend John DeAndrea show off their new baby boys, Marco and Duane, Jr., when the DeAndreas spent Christmas at our house in Florida (1973).

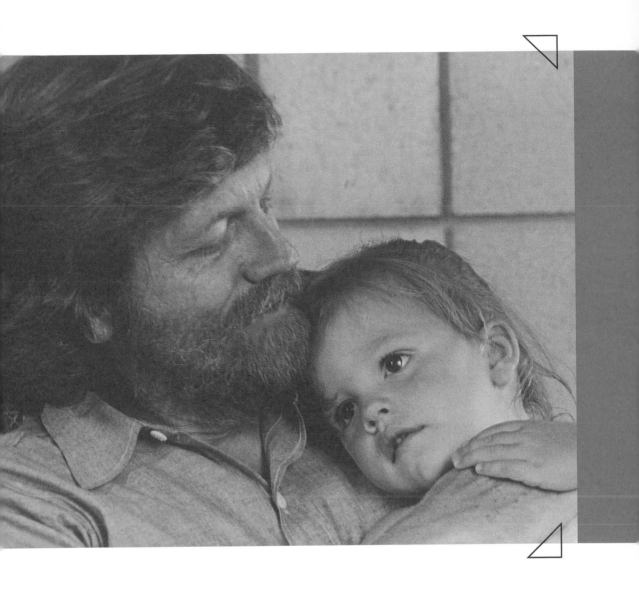

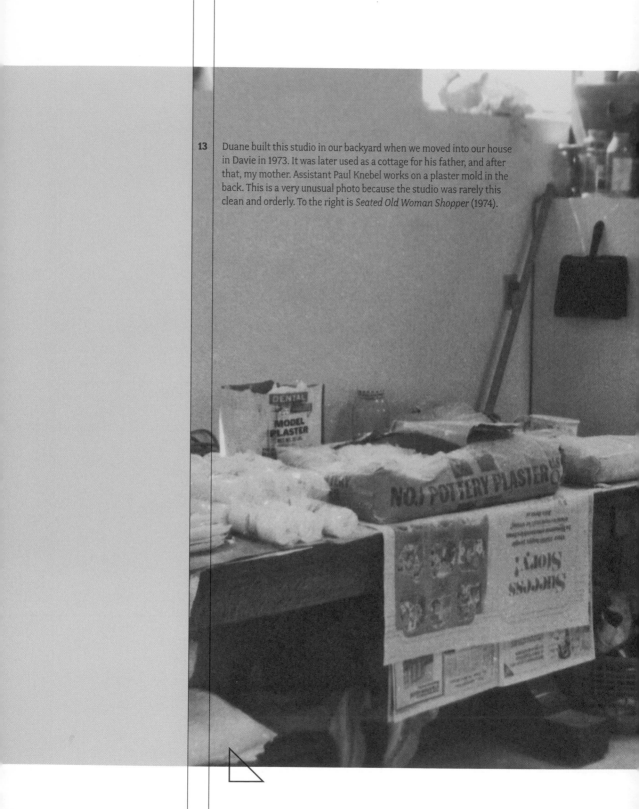

13 Duane built this studio in our backyard when we moved into our house in Davie in 1973. It was later used as a cottage for his father, and after that, my mother. Assistant Paul Knebel works on a plaster mold in the back. This is a very unusual photo because the studio was rarely this clean and orderly. To the right is *Seated Old Woman Shopper* (1974).

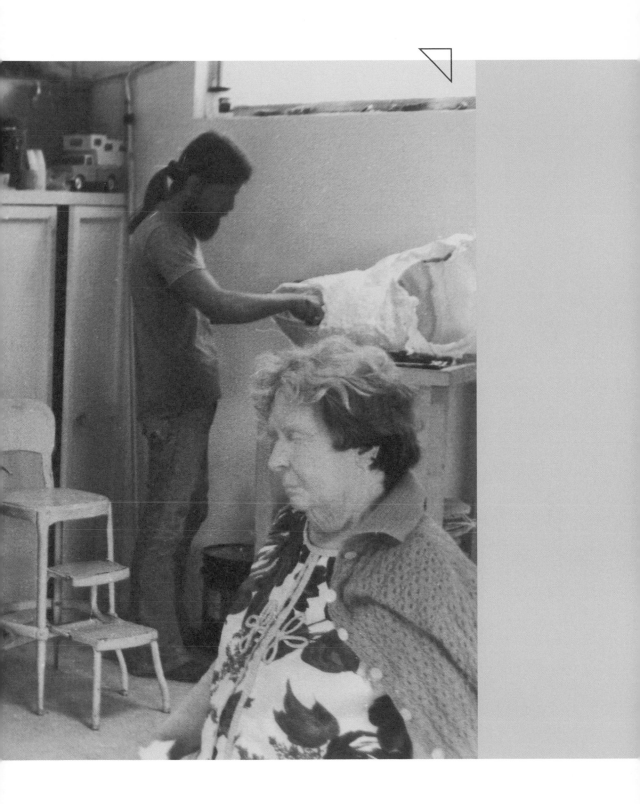

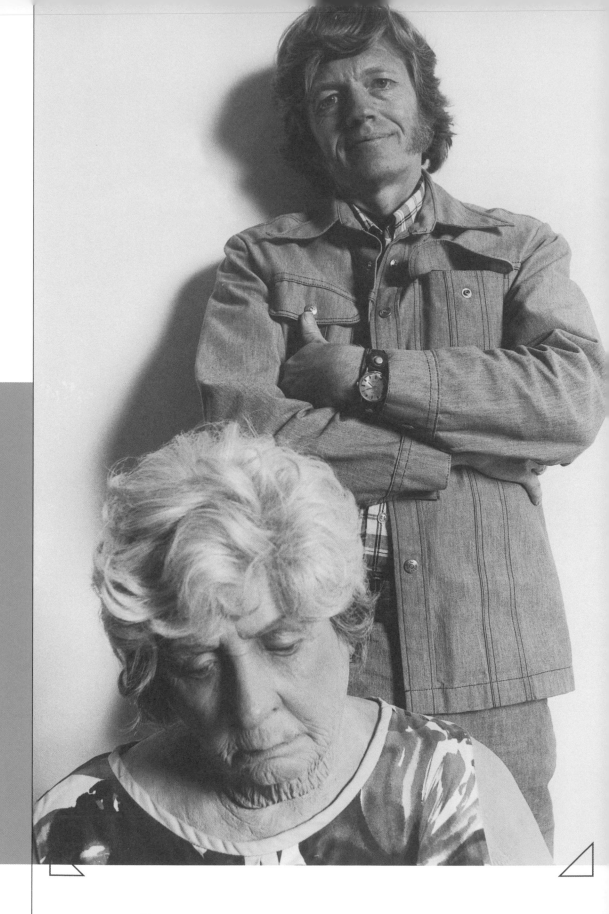

14 Wearing the denim suit that was later used on *Self-Portrait,* Duane poses with *Seated Old Woman Shopper* (1974).

15 Duane, with his children Maja, 5, and Duane, Jr., 2, in the front yard of his house in Davie. Duane grew up on a farm in Parkers Prairie, Minnesota, and felt that Davie was as close to being in the country as he could get in Florida (1976).

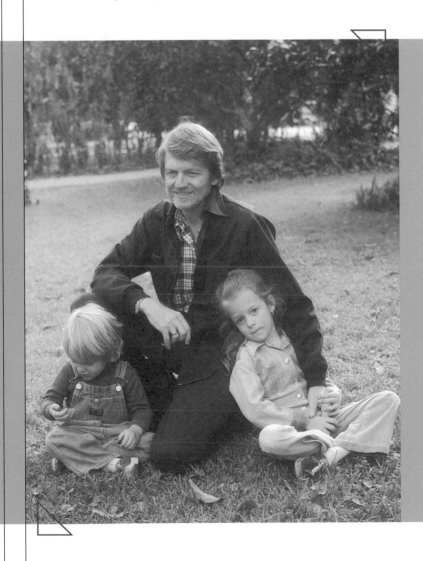

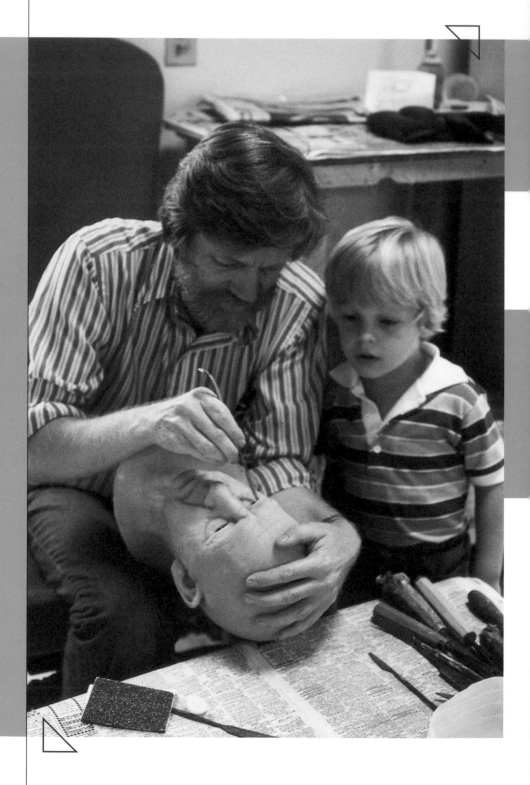

16 Duane, Jr., helps his father (1976).

17 In Philadelphia, Duane is standing on far left with artist Frank Goodyear (top in dark suit and glasses), an unidentified man and woman, and from left to right are artists: Stephen Posen (with glass in hand), Neil Williams, Al Leslie, Janet Fish, and Philip Pearlstein (1977).

18 (Below) Duane shows *Seated Artist* to Prime Minister of Canada, Pierre Trudeau, at the opening of his one-man exhibition in Berkeley, California (1978).

19 With *Man with Handcart* (1978).

20 (Overleaf) Typical shot of Duane talking to students. This one at Berkeley. *Tourists* almost blend into the crowd (1978).

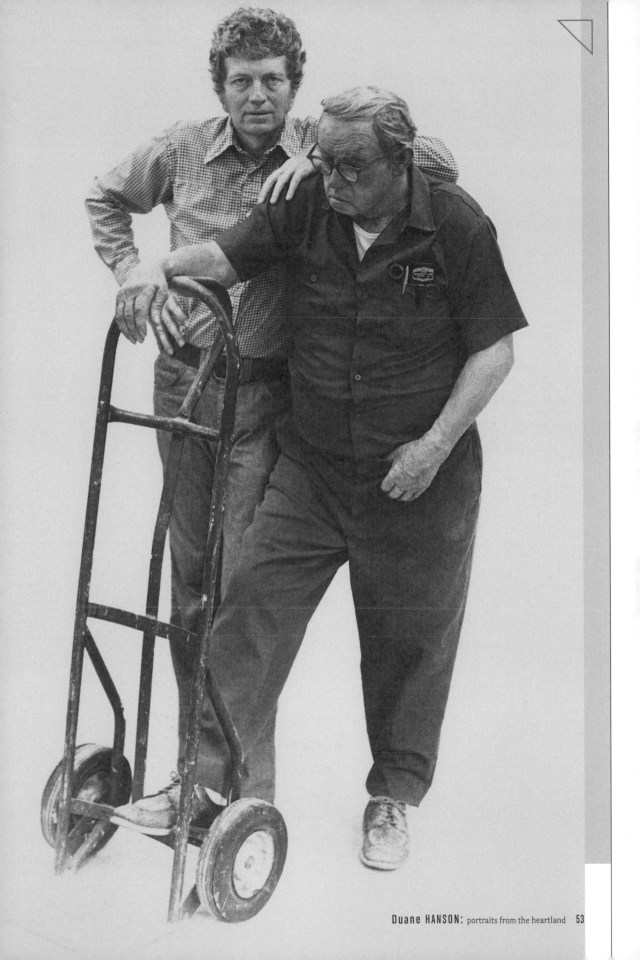

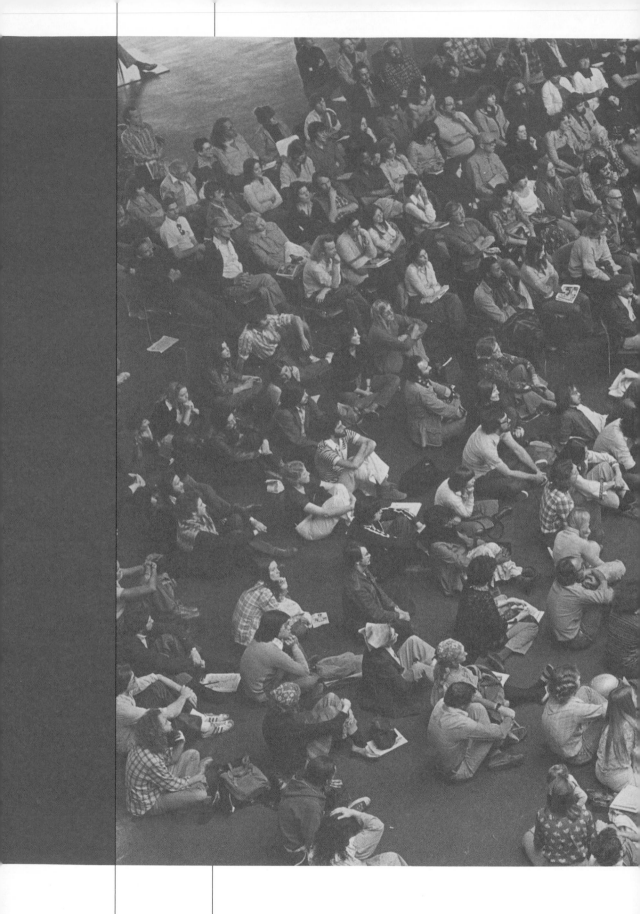

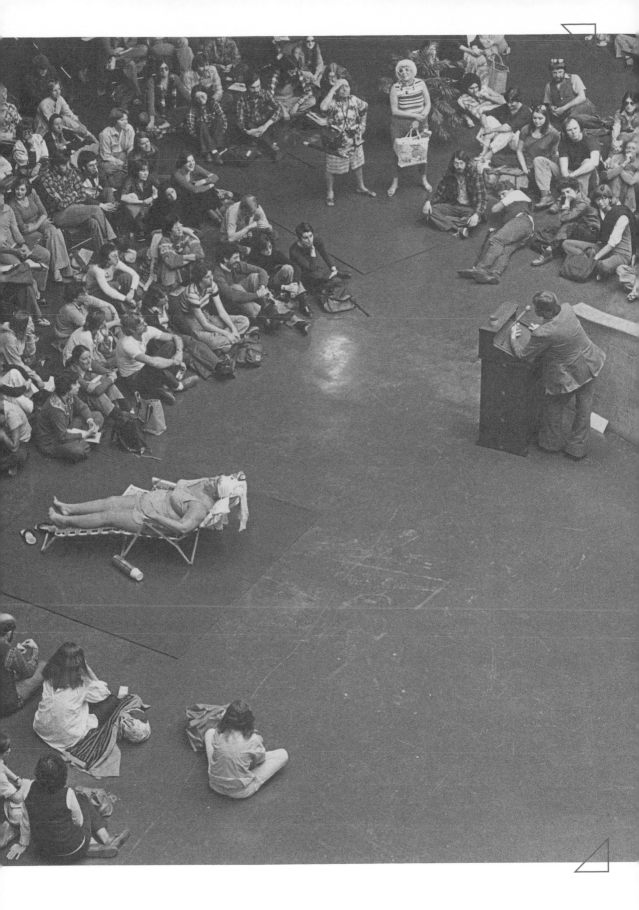

21　Under the glare of hot lights and surrounded by reporters, Duane fields questions at a press conference for his one-man show at the Whitney Museum of American Art, New York City. The show set new attendance records with people lined up around the block to gain admission (1979).

22 Andy Warhol and Duane at the Factory on Union Square in New York City. Duane and Andy were planning to make a trade of art works. Here Andy is taking the preliminary shots for his portrait of Duane, and was planning to come to Florida to be cast before his untimely death in 1987 (1979).

23 Duane being cast by me, for *Self-Portrait with Model* (1979).

24 Duane and his assistant discuss various poses for the artist in *Self-Portrait with Model* (1979).

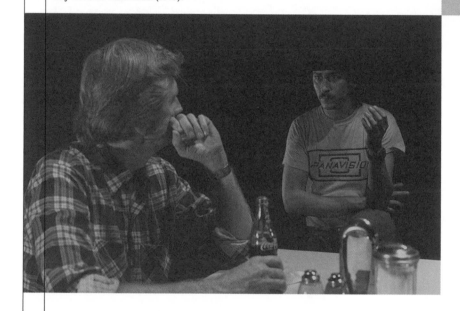

25 Duane shows *Seated Lady on Folding Chair* at Whitney Museum show (1979).

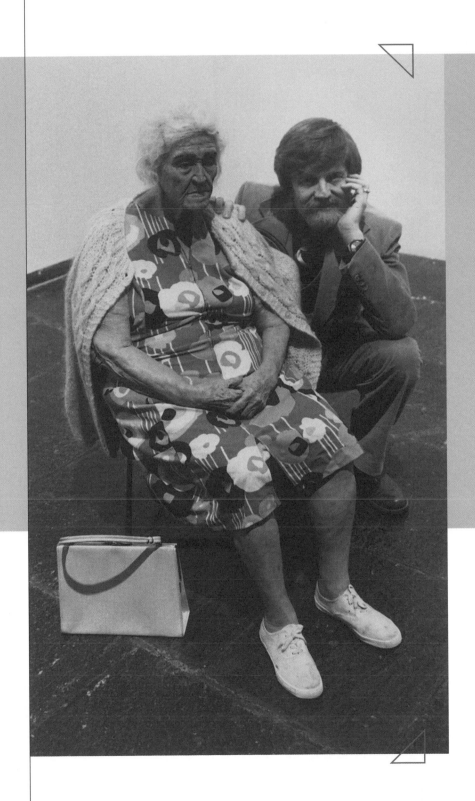

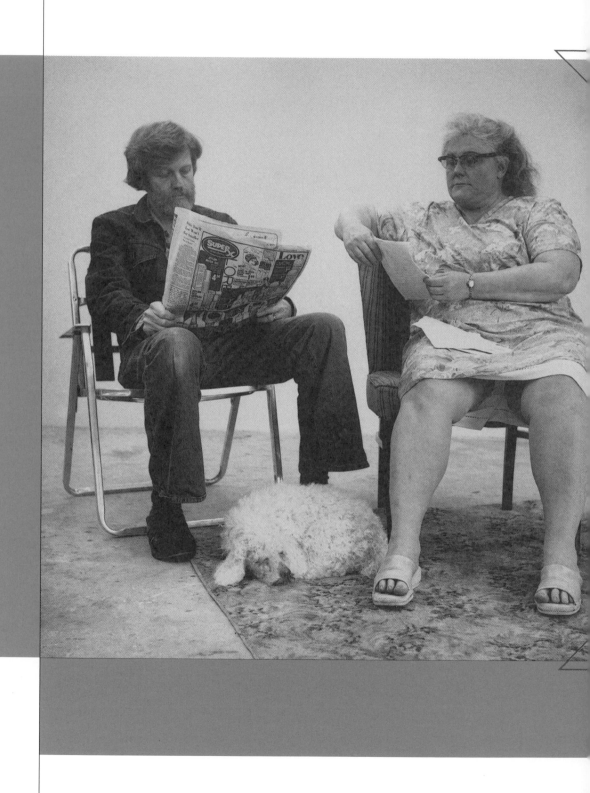

26 With *Woman with Dog* at the Whitney. At her feet is her miniature poodle, Pierre. This was the first sculpture Duane made of a dog, the second our beagle (for *Beagle in Basket*) (1979).

27 Duane pauses after making a cast for the leg of *Man with Crutch*, which was modeled by his brother-in-law Kaare Host (1980).

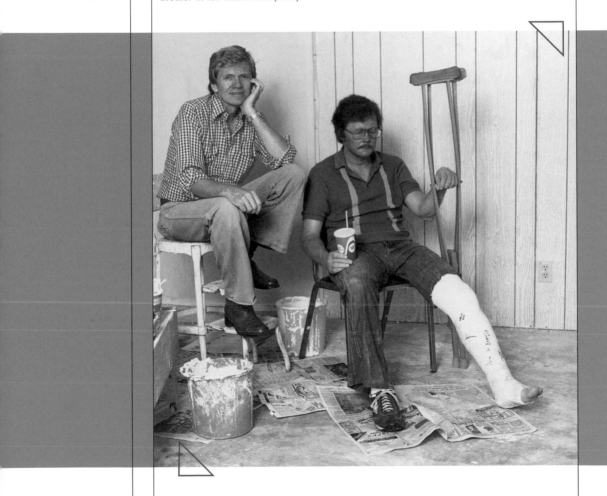

28 With looks of trepidation on their faces, Maja, 10, and Duane, Jr., 7, face the spotlights and questions with their father during a press conference at the Lowe Museum, Miami, Florida (1981).

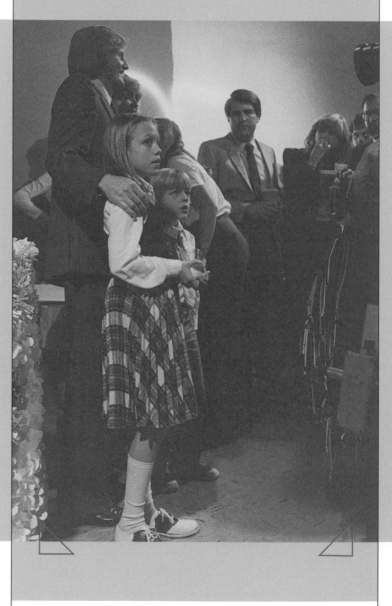

29 Duane with Leo Castelli, one of the most influential and prestigious art dealers in the world (1983).

30 Duane talks to Marty Margulies, collector and an early supporter of his work, while I look on. Marty has one of the most impressive collections of contemporary art and photography in the art world (1983).

31 Duane and assistant, Rick Reiss, apply plaster and fiberglass to the leg of model Mel Propis, for *Jogger*. We bought the house next door to our home in Davie, which was used as Duane's studio (1983).

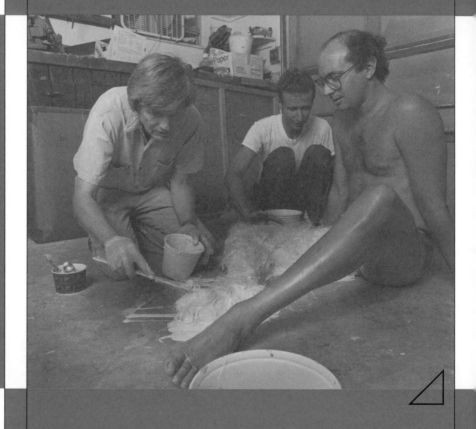

32 Clowning around at a photo session with *Jogger* and *Bus Stop Lady* (1984).

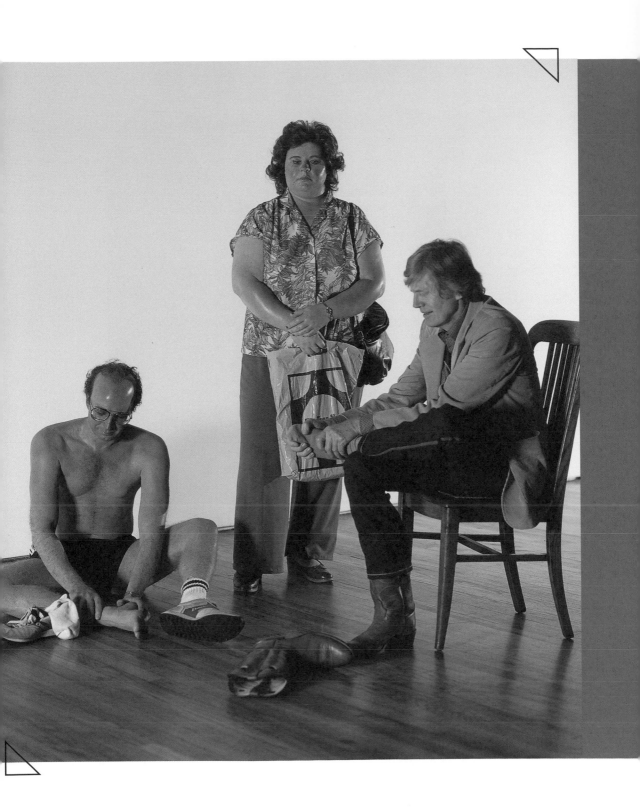

34 Accepting the Florida Prize of $10,000 for Outstanding Work in the Field of Visual and Performing Arts from then Governor Bob Graham at a black-tie gala in Sarasota (1985).

33 (Top right) King Carl Gustaf XVI of Sweden hosts a reception for Duane at his exhibition in Millesgaarden, Lidingo, Sweden. Since Duane is Swedish, and his grandparents did actually "come over on the boat" in the late 1800s, this was a great honor for Duane (1986).

35 Roy Lichtenstein poses with *Man with Handcart* in front of his painting (1986).

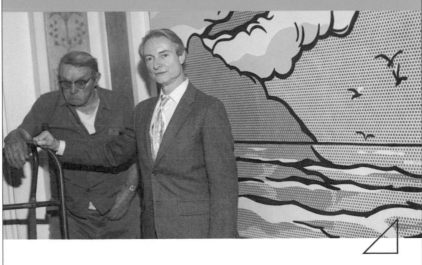

36 With good friends at John DeAndrea's house in California. From left, realist painter Richard McLean, John and Lissa DeAndrea, Duane, Jr., Duane, Darlene McLean. Daughter Maja in front (1986).

37 A student takes notes during a lecture and demonstration at the Museum of Fine Arts, Boston. Duane often demonstrated his technique by making a mold of a student's hand or face (1987).

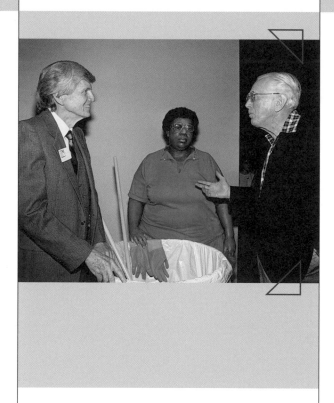

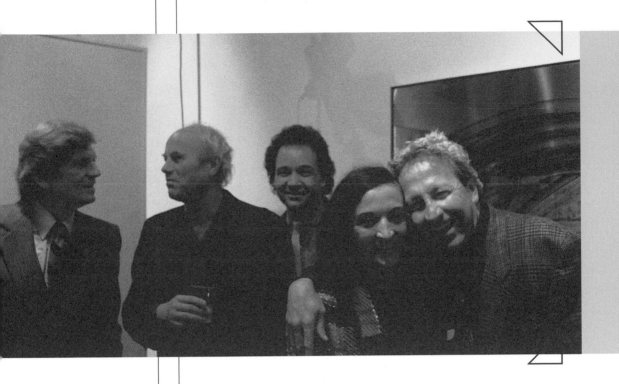

38 (Top left) Always friendly and generous with his time, Duane signs catalogs for art lovers at the Ft. Lauderdale Museum of Art, Florida (1988).

39 (Bottom left) Duane always enjoyed talking to Senator Howard Metzenbaum (D-OH), a strong supporter of the arts and an admirer of Duane's work. Here they share a conversation at an exhibition at the Ft. Lauderdale Museum of Art. Several of Duane's works were also exhibited in Senator Metzenbaum's office (1988).

40 Duane (left) chatting with James Rosenquist at an opening in Palm Beach. An unidentified man stands next to Rosenquist. In front, Bob Rauschenberg gives Marisol a friendly hug (1988).

41 Duane and close friend Larry Tobe, at a black-tie party for the unveiling of a bust he made of Larry (1989).

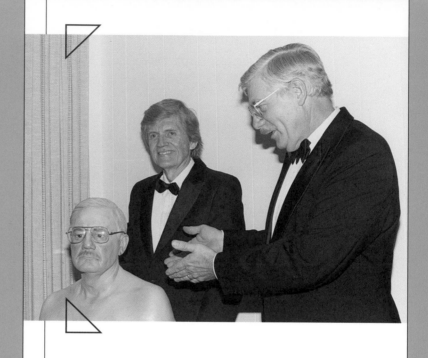

42 At his new studio in Davie, Duane clowns around with pal Paul Heidelberg, writer, who modeled for *Man with Camera* (right) and *Tourists II*. Unfinished *High School Student* in back (1990).

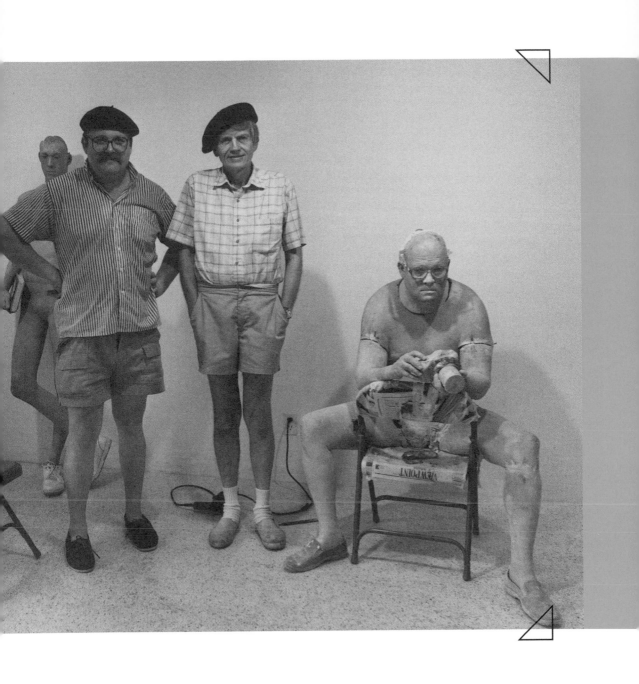

43 With art lovers Daryl Hall and John Oates, and *Sunbather* (1990).

44 (Below left) Duane with comic Martin Mull, fellow artist and graduate of Rhode Island School of Design, at a reception at the school in Providence, Rhode Island (1991).

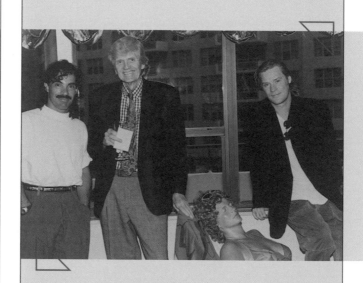

45 Duane would often check over the installation and do minor repairs on the sculptures before an opening. Here at the Kunsthalle in Cologne, Germany, he poses in front of a construction worker, part of *Lunch Break*, modeled by Scott Reed, long-time family friend and studio assistant (1991).

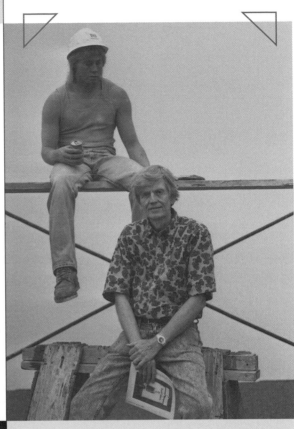

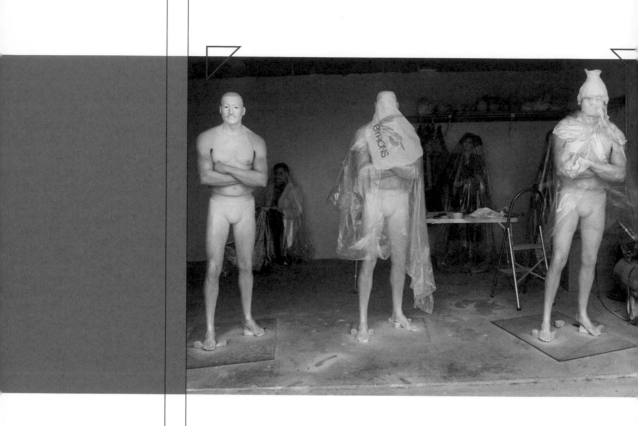

46 Three bronze editions of *Policeman* lined up for underpainting at the Griffin Road studio in Davie. This was done with enamel car paint and air compressor (1992).

47 (Top right) Duane, with Duane, Jr., student at Brown University and me (1992).

48 A wonderful day and proud moment for Duane on the graduation of daughter Maja from Rhode Island School of Design, Providence, Rhode Island. Son Duane a student at nearby Brown University (1992).

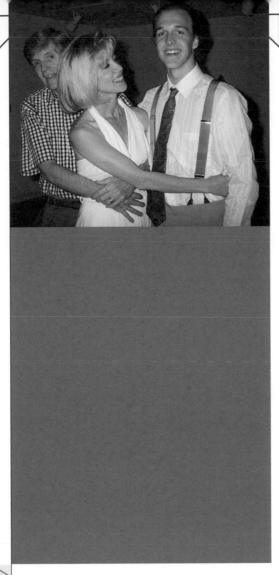

49 In Davie studio with Tin Ly and studio assistant Jennifer Basile. Both models for *Two Workers,* commissioned by the Stiftung Haus der Geschichte in Bonn, Germany, flew over to pose as authentic German workers. Duane spoke perfect German, so they got along famously (1993).

50 (Below left) The many faces of Mary Weisman. Duane worked for months from photos on the portrait of Mrs. Weisman, mother of renowned art collector Frederick Weisman. There are nine Hanson works in the Weisman collection (1993).

51 "Joan of Arts," as Duane called Joan Mondale, wife of former vice president Walter Mondale, admiring a construction worker at an exhibition in Japan. Duane's work was very popular in Japan, shown in three major traveling tours—1984, 1989, 1995 (1995).

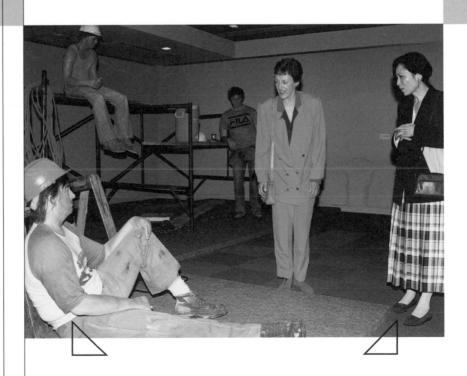

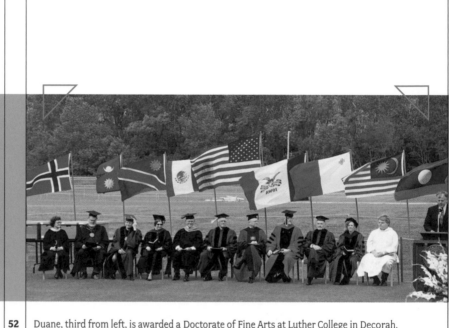

52 Duane, third from left, is awarded a Doctorate of Fine Arts at Luther College in Decorah, Iowa. Duane received three honorary doctorates during his career. His first came in 1979 from Nova University in Ft. Lauderdale, Florida, and in 1995, Duane received an honorary doctorate from Macalester College in St. Paul, Minnesota (1995).

53 Bronze *Man on Mower* at the foundry in West Palm Beach, put together and ready to be painted (1995).

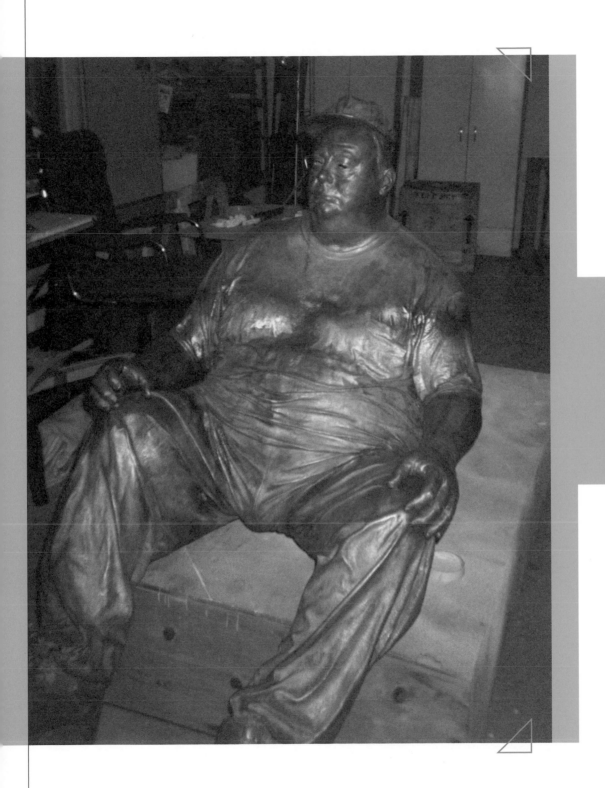

54 Duane and his assistant, Tin Ly, enjoy a laugh at the Griffin Road studio in Davie.
Two editions of bronze *Flea Market Lady* await assembly and painting (1998).

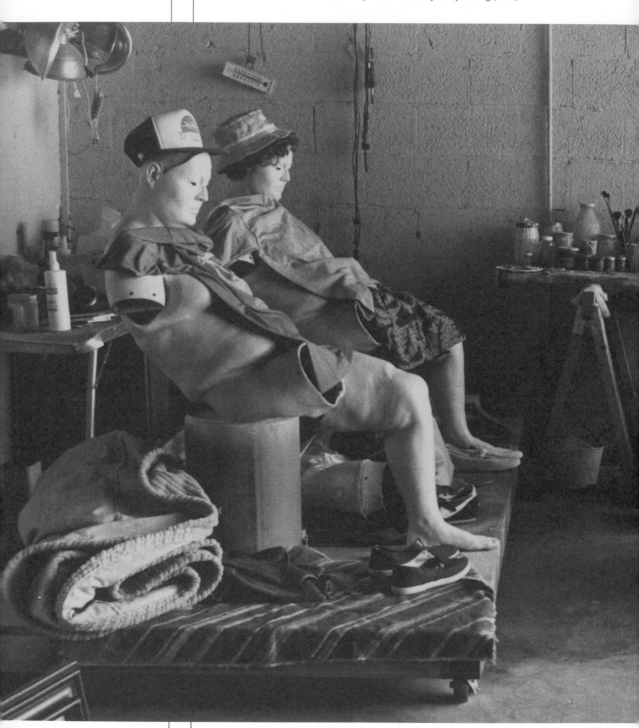

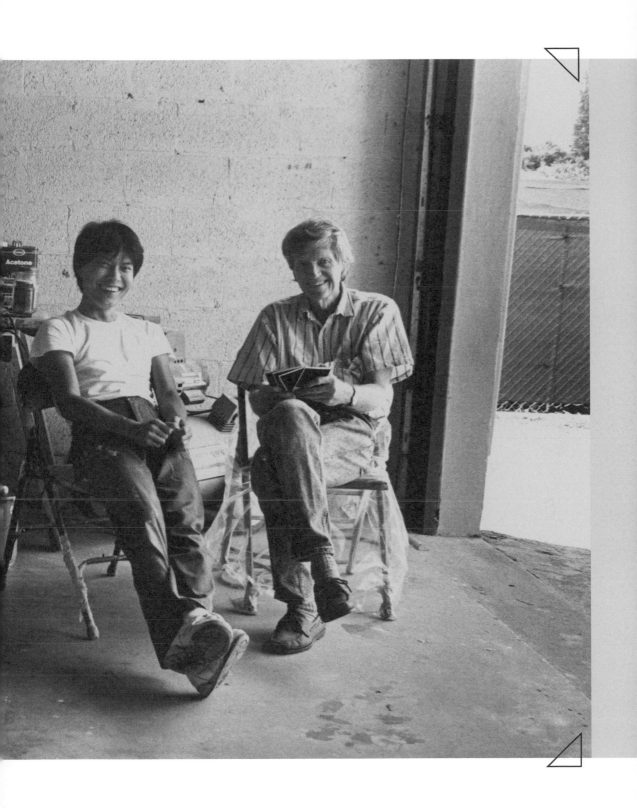

Interview with Tin Ly:
Duane Hanson's Long-Time Assistant

Rusty Freeman

INTRODUCTION

Beginning in 1985 and continuing until Hanson passed away in January 1996, Tin Ly worked closely with Duane Hanson as his assistant. Some individual works could take up to five or six months to complete. Often works would have several editions—an edition being similar to the original but with different poses or different clothes and accessories. As we shall see, Ly was a close collaborator with Hanson. Ly worked with Hanson longer than did any other assistant. To this day, Ly is actively involved with the art works, tending to their conservation and care, and assisting with their installation around the world.

Ly was born in Saigon, Vietnam, in 1953. His father, Cu-Minh Ly, and mother, Hung-Thuc Hung, were Chinese by birth, but moved permanently to Saigon in the mid 1930s. Ly vividly remembers growing up in the war-torn country of Vietnam in the 1960s, and having to constantly hide from the gunfire and tanks just outside his family's home. To escape the Ngo Dinh Diem regime and to have a chance for a better life, Ly was sent by his parents in 1971 to college in the United States. The rest of his family moved to Australia in 1978. Ly studied art and music at Indiana University, earning his Bachelor's degree in 1975. During his years of graduate work, he briefly focused on the combination of visual art and music with the study of scene design for opera. Ly also studied art in Europe and Australia. In 1980, Ly moved to Ft. Lauderdale with the hopes of establishing himself as a painter. It was there, in 1982, that he first met Duane Hanson at a local artist critique. Hanson singled out Ly's work for praise. Hanson later invited Ly to visit him at his own studio. The two eventually became friends, and in 1985 Hanson asked Ly to work for him as an assistant. The following year, Ly started "2+3, The Artists' Organization," and invited Hanson to serve as an Honorary Chair, further cementing the bond between the two artists, which was based on their shared interest in art and in supporting their local communities. 2+3 is still running strong today.

Also talented musically, Ly has been singing with the Florida Philharmonic Chorus since 1996. Ly also established, with the help of seven artist friends, the "3rd Avenue Art District" in downtown Ft. Lauderdale. The District is comprised of art studios that are open to the general public, the school system, civic and residential associations, as well as the country clubs and museums of the tri-county area for art lectures, workshops, charitable events, and gallery walks.

Ly has established himself as a painter with a long record of exhibitions throughout the United States and abroad. Ly has become well known in the state of Florida as an artist, arts advocate, curator, and educator. He currently works for Broward County Cultural Affairs in Ft. Lauderdale as a public art and design consultant. In 1995, the Smithsonian chose Ly for an important traveling group exhibition, An Ocean Apart: Contemporary Vietnamese Art from the United States and Vietnam. *Ly has worked for some time to combine painting with sculpture, and recently had a one-person exhibition at the Vero Beach Museum of Art titled,* Substance and Shadow, *featuring his large-scale painting/sculpture installations. He has shown his work at the Museum of Art, Ft. Lauderdale, and the North Miami Museum of Contemporary Art, and his art may be found in the collections of Museum of Art, Ft. Lauderdale, and the Art and Culture Center of Hollywood, Florida, and private collections.*

With Ly's commitment to community, it is perhaps easy to see why he and Duane got along so well and for so long; both men are keenly interested and involved in their local communities. In 1999, Ly completed a 60-foot mural titled, "Communal Dream," which is on permanent display at the Broward County Central Homeless Assistance Center. To establish a direct and personal connection with the shelter's future tenants and the mural's subject, Ly asked homeless residents staying nearby to sketch out their favorite places or to describe what they would do after they left the shelter. Ly transcribed their images into his work of aluminum reliefs and sandblasted drawings directly onto a concrete wall. Ly's declared goal was to "elevate the expression of homeless people's lives."

This interview with Tin Ly, Duane Hanson's assistant, was conducted by Rusty Freeman, vice president for collections and public programs at the Plains Art Museum. It was conducted via email on the dates of April 21, May 12, 20, and 22, 2003.

Tin Ly standing next to his painting, *Langit Ku Rumah #5,* 1996.

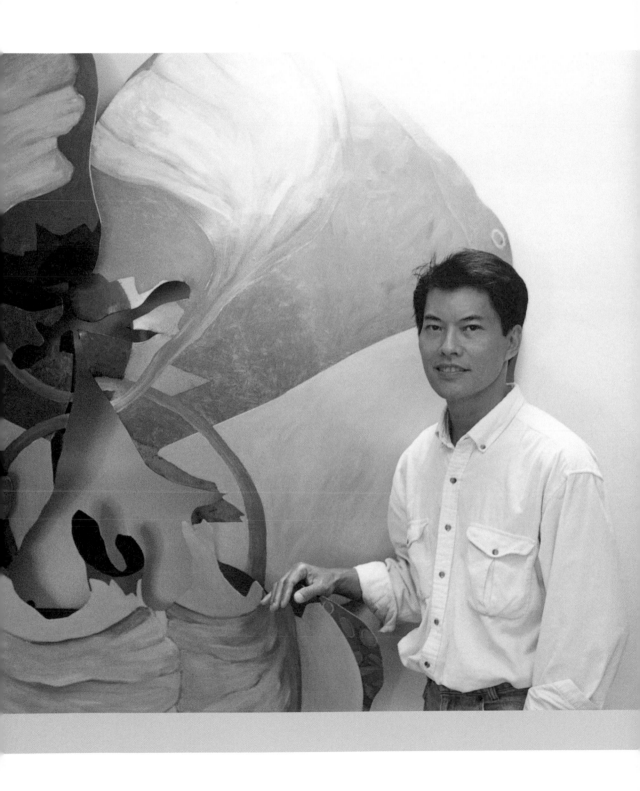

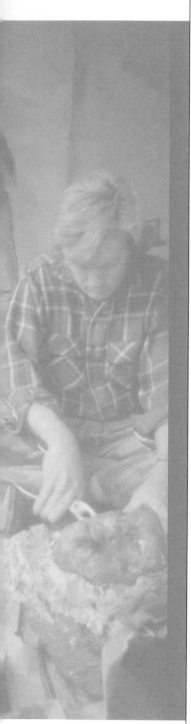

Rusty FREEMAN: *You first met Duane Hanson at a Broward Art Guild critique session in 1982 and became his assistant in 1985. Recreate the moment for us: describe that first meeting, how you met, and what led to you becoming his assistant.*

Tin LY: In 1982, I first met Duane at a private gathering of artists for an informal critique by Hanson, organized by a member of the Broward Art Guild. I was thrilled to be invited to attend this gathering and to submit my work for—hopefully—some words of encouragement. Duane was well known and respected in the art community. He was a bit guarded at first, knowing that he did not want to offend anyone. Yet, he was quite effusive to point out the futile exploration of appropriation and sentimentalism. He definitely went for work that was well crafted and well thought out in the context of contemporary art. My works were well received by Duane who singled out a photographer's work and mine in a later newspaper interview about the critique. He subsequently invited me to visit him at his studio in Davie. His studio, located next door to his house, was a converted regular house with a large addition, about 20' x 25', which he used to do life casting and some finishing work. Mold making and resin pouring were done outside in the open space. The rest of the studio was his office (he did not own a computer), library, a living room converted into a display area where he installed some of his works and works by his artist friends, and a well-equipped kitchen where many lunches were prepared and served. After that initial visit, we crossed paths several times in social gatherings. Over the next couple of years, I visited Duane often at the studio. Then, in 1985, he invited me to be his assistant.

RF: *What was the first piece you worked on with Duane?*

TL: I became his assistant in May of 1985. The first life casting we did was on his children: Maja (*Cheerleader*) and Duane, Jr. (*Surfer*).

RF: *Take us through an average workday with Hanson. Describe how a typical project would unfold, how Duane would get started with a new idea or subject, and how the two of you would see it through to completion.*

TL: Duane was not an early riser. He was in no mood for serious working until late morning, with the exception of a life-casting session day, which usually started around 10 am. But, he worked late at night. I believe that he worked best at night.

From 1985 to 1989, I assisted Duane only during the life-casting sessions. He had another young helper, Scott Reed (who is the model of the young worker sitting on top of the scaffolding in *Lunch Break*), a high school friend of Duane, Jr., and Maja, to help him in doing the lay-up of the mold, pouring fiberglass resin into the mold, breaking the mold, and rough sanding. Duane put all the parts back together, fine tuning (this was the longest part of the process, due to his tireless approach to realistic appearance), and added anatomical details if lost during the lay-up. Also, he would alter the forms to get what he was after from that particular work/character. I was called in occasionally when they needed an extra pair of

hands. Gradually, Duane introduced to me the finishing process of his work: painting, hair planting, clothing, and accessories set up.

Then, from September of 1989 till his death, I was assisting him with the finishing work for all his sculptures. We set up a separate studio in Ft. Lauderdale just for the finishing process of the sculptures.

RF: *How did Duane select the kinds of people he would portray? Did you ever suggest people to portray?*

TL: Most of the sculpture subjects were decided solely by him. He knew what was interesting to him. To reproduce the exact likeness of the model was not his priority. He was only after a certain personality that the model had. But, foremost, he was after a sculptural presence; therefore, he would often modify the physical appearance of the model by adding more volume to the body or a feature of the sculpture.

The way he selected his model, he would go through his friends first to see whether anyone fit into a character that he was after. Then, he might enlarge his circle of candidates to search for friends of a friend. Finally, someone we ran into on the street (an outsider) would be his last resource.

Sometimes the historical event influenced his choice: *War* (1967), *Policeman and Rioter* (1968), *Bowery Derelict* (1969), and *Chinese Student* (1989) were related to a particular historical or social happening. He did want to make a Vietnamese Refugee and asked me to model for it. But, I refused and he accepted my decision. I ended up as the model for the *Chinese Student.* I did suggest a model for a "baseball player," which did not materialize.

RF: *Did you ever suggest creative solutions for the work? What about practical solutions: there was a lot of problem solving for these involved works. What was the hardest practical problem you had to solve?*

TL: Since I have been trained as a painter, I brought along painting technique to the finishing process: translucent layering of egg tempera or the semi-transparence of oil glazing technique which was translated into layering of thin pigmented automotive paint with air brushing onto the surface of the sculpture. Duane used to finish the sculpture by painting with oil directly onto the surface. He aimed at the final coloring and details at the onset, while I built layer upon layer of paints to achieve the transparency of the flesh tone. Yet, his painting technique was very appropriate for his early works, which were more expressionistic in the general presentation and style.

We did talk a lot about poses for a work to get the most meanings out of it. This almost leaned toward a psychoanalysis of a gesture, a glance, a piece of accessory, or a particular color combination in the clothing. Because it is a sculptural form that we were dealing with, and yet there was a particular physical angle from which to look at the work—the best angle, as in a "tableau vivant." From this best angle, all things fall nicely together: colors flow from the sculpture with its clothing to the accessories, back to the sculpture, to the direction of its glance, etc.

RF: *When you two were just working on producing a piece, simply making it, what did you talk about to pass the time of day? Duane was a huge fan of Wagner and opera music. What kind of music did the two of you listen to when you were working together? Did you have favorite restaurants?*

TL: He did not have the music on when we worked. We had to concentrate and he did not put on his hearing aid while we worked. We talked about daily events around the world or happenings in the region. The music hour of Wagnerian operas, Richard Strauss, and some Puccini, was reserved for special evenings of "opera club" gatherings in which a bunch of friends met at either Duane's studio or a friend's house to watch or listen to opera. He would sing along with the recording in the car when we had to travel to a distant meeting place or to the foundry in West Palm Beach.

We did lunch on Thursdays with an old friend of his, Mary, at a diner in Davie [Florida], not too far from his house. On Thanksgiving, he invited me for the feast. Wesla often cooked a large goose instead of turkey. Duane kept live turkeys as garden pets.

RF: *What was it like having the tables turned, when you became the subject and model for Duane's 1989* Chinese Student? *How arduous a process was it?*

TL: The life casting was done in one day. By 1989, we had the procedure of life casting down to a science: x-amount of time for the legs, x-amount of time for the trunk, x-amount of time for the arms, and last, x-amount of time for the head. The head is the most difficult and time-consuming part, with a lot of preparations done carefully, such as greasing the hair, eyebrows and lashes, ears, and face to minimize the hair pulling experience for the model. So, when I became the model, Duane and Scott worked on me, like real pros. I was so used to being told by other models of their hair pulling, and the claustrophobic experience, that I was well prepared. In fact, I enjoyed my experience: there was an inner peace when my head was completely covered by the polymer gel and plaster: an overwhelming sense of isolation of sight and sound, and a certain heavy weightiness due to the plaster encasement for the mold. That lasted for 15-20 minutes, but it took half an hour to prepare the head.

RF: *On a more pragmatic level, why did Hanson decide to work in bronze? How hard was it to change from the polyvinyl to bronze? Any special considerations for bronze? How do you get clothes on a bronze sculpture?*

TL: Duane started casting his work into bronze around 1984, before I became his assistant. But, he later did talk about some of the reasons that influenced him to take that direction. First and foremost, bronze is a time-honored, well-tested medium for many centuries. From the conservation point of view, bronze would outlast polyvinyl and fiberglass resin (both media were used extensively in his works of the '60s, '70s, and early '80s) by a very long shot. Structurally, bronze could sustain far more abuse than the other two media. But, the painting and finishing of the bronze by transforming it into a very soft and tactile flesh-like surface was very challenging. That was the trade-off. In addition, the painted surface is very

fragile. Any blemish of the surface would interfere with the realistic illusion. So, we have a very strong and permanent material as substrate but covered by a very fragile surface finish. On a pragmatic level, casting in bronze allowed an edition of several pieces instead of a unique one as the polyvinyl and fiberglass resin can only allow. It is a solution to meet the market demand. But, each bronze from an edition does have a certain element of uniqueness, due to the painting plus clothing and accessories variation.

The clothing for a particular sculpture was included in the planning stage of the sculpture before being cast into bronze. Depending on the style of the cloth, such as long sleeve or short sleeve, loose fit or tight fit, button or zipper, etc., and depending on the pose of the sculpture, Duane would put in a Roman joint at either mid-arm(s) or mid-thigh(s) for easy dressing. Each sculpture has its own predetermined set of joints.

RF: *What is a "Roman joint" and how does it work?*

TL: "Roman joint" is a technical term pertaining to a specific structural joint for sculpture making. In figurative sculpture, this joint allows the two parts to be separated and then

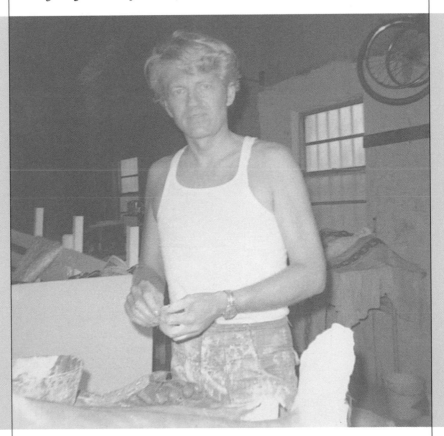

His sculptures represent the ultimate "Other" within the context of the art museum and its dominant clad-in-black crowd.

rejoined at a precise location. The joint is well constructed with overlapping inner connectors that are further reinforced with screws from the outside, so that the connecting parts can be securely attached.

RF: *Did he have any particular favorites? What are your favorites?*

TL: I do not recall that he said he had any favorites. Most likely, he preferred the ones that successfully portrayed an aspect of Americana. But, I do have my favorites of his work: *Rita* (1975) and *Old Man on a Bench* (1978) from the Saatchi Collection; *Queenie II* (1988) and *House Painter* (1988) from Wesla's collection.

RF: *Artists in the United States have had a long history of recognizing the working class in their art. John Sloan and the Ashcan artists, Mary Cassatt, Thomas Hart Benton, Diego Rivera, Jacob Lawrence, right down to the Pop artists, all recognized in paint a particular disenfranchised class in America. Certainly the peculiarly American melancholy of Edward Hopper's work connects directly to Hanson's work.*

The term that you use, the "Other" implies an isolation, and there is a clear recognition of that isolation by Duane within the context of contemporary art. He completely defied the reigning art word, and that was very positive. I think that he was very comfortable with that position.

Before Hanson, was there anyone in the history of art who chose to depict the average person in sculpture to the degree than Hanson has? You noted at the time of his death, that few artists were exploring the social and psychological subject matter that Duane Hanson did. Why do you think it fell to Hanson to do this?

TL: If we are putting his work in the context of art history, there are other artists who had dealt with the theme of the "working class." Degas, Manet, Hals, Max Beckmann, John Sloan, Alex Katz, etc., all looked at the working class, but not to Duane's degree of exclusiveness. Duane had worked in the sculptural medium since he was a young man (*Blue Boy*, 1938, and other small figurines), and had experimented with the style of abstraction and expressionism in the early stage of his development. With the advent of new synthetic materials in the mid '60s, he started to experiment with full-body casting. His interest in figurative sculpture was a personal, subversive reaction to abstraction and minimalism of the time. I also think that his upbringing in Minnesota had imbued in him a certain value system that could have affected his choice of subject matter for his art. He felt most at home with ordinary people of working class. To put it simply, he did something that he felt for, related to, and understood well.

RF: *There have been other social commentators in sculpture—such as Edward Kienholz or George Segal—but Hanson set himself apart to a remarkable degree by presenting his subjects "as is" (to use Warhol's notion of Pop Art). Hanson sculptures are typically understated, little obvious emotions are depicted. Of course, his earliest works were very expressionistic and shocking. Did you ever discuss with Duane why he chose the emotional understatement for most of his works? Even Chinese Student, which he made out of disgust and in response to the 1989 Tiananmen Square massacre, is a reserved piece compared to his earlier work. Did he ever talk about using the more overt strategies of his earlier work?*

TL: His earlier "expressionistic" works such as *War* (1967), *Motorcycle Accident* (1967), *Policeman and Rioter* (1967), and *Football Players* (1968) are works that attempt to arrest a moment in time, to freeze an emotion, or a movement. Then, he realized that a suspended motion was not believable. For example, a big and happy smile with teeth showing cannot last forever, thus cancels out the believable illusion of a real person. Subsequently, he had destroyed other works from this period because they were not what he was after.

Time is a constant flowing dimension. He had to find a way to contain a movement—energy reserved—yet give an illusion of the possibility of continuous movement into the next timeframe. Therefore, he was attempting to have his figures portray "contained energy," enabling the figures to come from the "past tense" and ready to go to the "future tense." In a sense, that reminds me of the energy contained and generated in the standing figures by Giacometti. If you assert that Hanson's figures have little obvious emotions depicted, that is because they were made to arrest an action, relaxed, and ready to gather up energy to show the next motion or emotion. All is under the operative of the most effective and believable illusion of realism.

RF: *The works themselves seem to subvert any pure aesthetic reading of them as just sculpture. They are very real and convincing, with little of the artist's hand in evidence, and because they are so human-like, you try to interpret them based solely on a psychological reading of them. But this seems to me to be a rather narrow approach. They operate in many of the contexts through which we now try to understand art. In 1999, Peter Schjeldahl referred to Hanson's art as one that "economically sums up much of what new art was most urgent about in recent times." For example, they represent the ultimate "Other" in the sense that when they are seen within the context of the art museum and its dominant crowd of the hip, chic, clad-in-black crowd, they become clearly recognized as the "Other." It seems that Hanson was very aware of their potential contexts, particularly that of the art museum, and how they would operate within that environment. One of his last works,* Man on a Mower, *was originally planned to be placed outdoors, giving it an altogether different context than his previous works. Hanson seems very aware of how his work operated within different contexts. Do you agree, and did you and Duane ever talk about how the context would affect the works' meaning?*

TL: The term that you use, the "Other," implies an isolation, and there is a clear recognition of that isolation by Duane within the context of contemporary art. He completely defied the reigning art world, and that was very positive. I think that he was very comfortable with that position. The notion of elitism repulsed him; therefore, he insisted that his work be presented without pedestal and be fused with the general setting, to partake in the ongoing activities of the surrounding. This is another aspect of the context that confused the critics of the time: the works further diffused the notion of high and low art.

One of his last works, *Man on a Mower* (1995) was intended to be part of an outdoor art festival organized by the former Marisa Del Re Galleries of New York and Monte Carlo. The Monte Carlo venue has a large outdoor garden; Duane thought that a *Man on a Mower* would be perfect for the setting, to further confuse the art and reality. And this is the only bronze in his oeuvre that everything (including clothing, shoes, cap) was made of cast bronze and paint, except, of course, the mower.

Tin Ly, **Langit Ku Rumah #2,** 1996, oil on steel

Precisely because of the fact that the setting and the context of the placement of his work could affect the reading of the work, it is very important to install them in a museum exhibition where there are many works installed together within a single large room. The works could engage in dialogue with each other that could change the meaning and so on.

RF: *Today, we are still concerned with the media and its manipulation and infiltration of our lives with images of false glamour and physically perfect bodies. Yet it seems that early on, and appropriately, Hanson responded to that condition by representing subjects who typically were not a part of the media hype, and even went one better by placing them within the art context. Hanson realized that we are seduced by media-driven glamour, and to counter that, he confronted us with a version of ourselves. Did you and Duane ever discuss issues like the media and its effects on us?*

TL: Duane preferred reading a good book, especially biography or history, to watching TV. Of course, he did watch news. He was not influenced by what was going on in the high-society circle. Media-driven glamour was definitely not his cup of tea. If he portrayed some character with heavy weight, aside from the implied psychological and sociological reading, he was after the sculptural form. Mass equals to volume equals to sculptural presence.

RF: *Although Hanson always insisted his work was about recognizing the humanity in these overlooked people, his was a rather brilliant art move that has strong affinities to Duchamp and Warhol. Duchamp challenged the context of the art gallery by wanting to place an ordinary, unaltered urinal in that setting, upsetting the perception of what can be an art object. Warhol turned that Duchampian notion on its head by painting the "ready-made," such as the soup can, and then re-presenting it in the art context. Hanson in a bold, bold move, ups the Duchampian and Warholian gambits by introducing "real" people into to the gallery context, thus adding a huge and very significant sociological aspect to the content of the "everyday." It is a wonder Warhol himself didn't make more of Hanson's work. Hanson was one of the few, if not the only artist to merge the concepts of Pop Art and Photorealism into one presentation, and then confound any reading of the work because the subjects were so real, taken from life. I believe if Hanson hadn't been such an ardent proponent of the works' social component, his work might have been recognized sooner for the deft manipulation of the art context that he achieved. Did you and Duane ever talk about how these works function aesthetically, how artful they are, even though they appear to have no art at all?*

TL: I agree that it is a strange twist from the bold move he made to introduce "real" people to the gallery context and that the works appear to have no art at all. The work is so effortlessly presented that all reading is possible and impossible at the same time. Maybe this apparent quality of the utterly unclassifiable, perfectly simulated sculpture stops critics from looking further into the significance of the work.

RF: *There seems to be a different appreciation of Hanson's work in Europe as compared to here in the United States. The Germans in particular seemed to have appreciated and understood Hanson on a higher critical level sooner than did his home country. You have worked on Hanson exhibitions abroad. Would you talk a little bit about the differences you see between the two countries' understanding of the artist?*

TL: The European culture has a long tradition for the making of figurative sculpture. They view the figure as an expression of the soul. With Hanson's work, they see another dimension of that expression, which has not been achieved in art up until then. Further, the Germans see an utter existentialist content in Duane's work, in a most minimalist presentation, unlike Kienholz and Segal works, which rely often on an extensive backdrop of props in order to create a complete defined story telling. Also, Europeans are fascinated with all things American.

RF: *Were there any exhibitions that you two worked on that hold some special meaning for you?*

TL: The exhibit in the Montreal Museum of Fine Art (1994), where a gathering of some of his seminal works from the 60s (*War, Policeman* and *Rioter*) together with his later works, all installed individually with each sculpture in its own room. That was the ultimate setting to read correctly the content of Hanson's work in a museum setting. Other exhibitions, Joseph-Haubrich Kunsthalle in Köln (1991), Kunsthaus Wien in Vienna (1992), Diamaru Museum of Art in Tokyo (1995), and other venues all hold special meaning for me.

RF: *What was special about these exhibitions?*

TL: I worked alongside Duane in setting up the exhibitions at Kunsthaus Wien in Vienna and at the Montreal Museum of Fine Art. I learned the way in which Duane would like the sculptures to be installed: the very minimum space required between two sculptures before they break down in meaning; the best angle to be viewed; how the traffic flows in relation to the location of each piece; how to avoid unwanted storytelling between two or three works in the same gallery space; how to light each work and where to light it; and even the way to handle each sculpture from the crate to the site. In 1995, Duane was quite ill, so I was sent for and, for the first time, was in charge of the installation of his works at Diamaru Museum of Art in Tokyo. Ever since then, I have been consulted on the planning and installation of all major exhibitions of his work.

RF: *How do you think about Hanson's work today? Has your perspective changed since you began working for him almost 17 years ago?*

TL: The significance of his work reveals itself gradually to me the more I understand what art is about. He has occupied a unique position in the development of art that has a universal appeal.

RF: *How has working with him influenced your own ideas about art in general, and your own art?*

TL: I cherish the experience of assisting Duane very much. He has been my mentor in a lot of ways. I learned from him about how to focus one's vision and to experiment until there is a perfect fusion between the making of the art and one's own vision and idea.

RF: *Part of Hanson's poetry, it seems, is to oscillate between reality and fiction. Most critics have skipped over the sculptures' aesthetic, and gone right to the content, its sociological aspects. When you think of other artists who have made art from life, for example, Jasper Johns'* Savarin Can *(coffee can filled with paint brushes), or Warhol's* Brillo Box, *or Vija Celmins'* To Fix the Image in Memory *(rocks), why do you think their aesthetic or style of presentation was lauded much of the time over the work's inherent content, and Hanson's which combines convincing reality with a humanitarian content would be ignored such as it has been?*

TL: Duane's work is accessible to everyone. His subject reveals itself at one glance. He did not use any distortion to engender mystery, nor did he transform the material into something other than flesh and soul. The examples you use of the contemporary art convey more of a concept with open-end reading, which is favored by the conceptually oriented theorist. Duane focused completely on the process of the making of art and perfecting of the craft to render an inert material into flesh and soul.

RF: *What do you make of the recent artists who seem to be interested in Hanson's work, for example, Sharon Lockhart?*

TL: Because Duane had broken down the barrier in figurative sculpture, the distinction between high and low art, getting rid of the pedestal, embracing the context of the museum as a setting to test his own idea; he has opened up new possibilities for other artists to further experiment with scale and appropriation. The art goes on.

RF: *What don't we know about Duane Hanson that you'd like us to consider?*

TL: Duane did a few easel oil paintings toward the end of his life. These paintings focused on his love of nature: landscape of the lake by his summer home in New Hampshire. Also, he loved to raise fowls in his backyard: turkeys, peacocks, and Chinese Golden pheasants. A big happy family!

RF: *How would you characterize the legacy of Duane Hanson?*

TL: Duane's persistence and single-mindedness in portraying the working class of middle America, dealing with the subjects one encounters everyday, he challenged us to look deeply into this world that we inhabit, to elicit our understanding of our inherent vulnerability. It is painful to confront one's true self, to stare at mortality—the ultimate destiny—in its face. Duane was not a "religious" man in a conventional sense (I do not recall seeing him attend church), but he created an oeuvre of the most religious, figurative sculpture in the 20th century.

RF: *As a last word, you and Hanson have been very supportive of the local artists in your community. Based on your long relationship with an artist who was committed to recognizing others, what advice would you offer to artists?*

TL: Be confident of your own vision and find a way to realize it. Be persistent and patient to refine the process of art making. By all means, be humble.

To borrow an inscription Duane wrote for me in his 1992 catalog published by Neuendorf Gallery in Frankfurt, "As the man said: Make something truer than Nature—That is the complete art." ■

How would you categorize the legacy of Duane Hanson?

Duane's persistence and single-mindedness in portraying the working class of middle America, dealing with the subjects one encounters every day challenged us to look deeply into this world that we inhabit, to elicit our understanding of our inherent vulnerability.

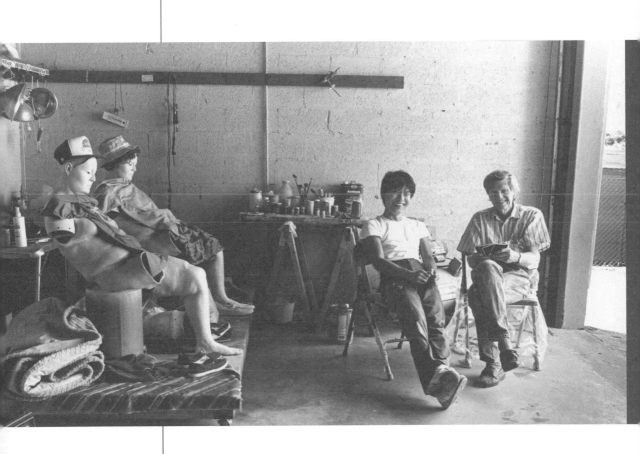

CATALOG

Anna Goodin with Duane Hanson, Jr. and Maja Hanson

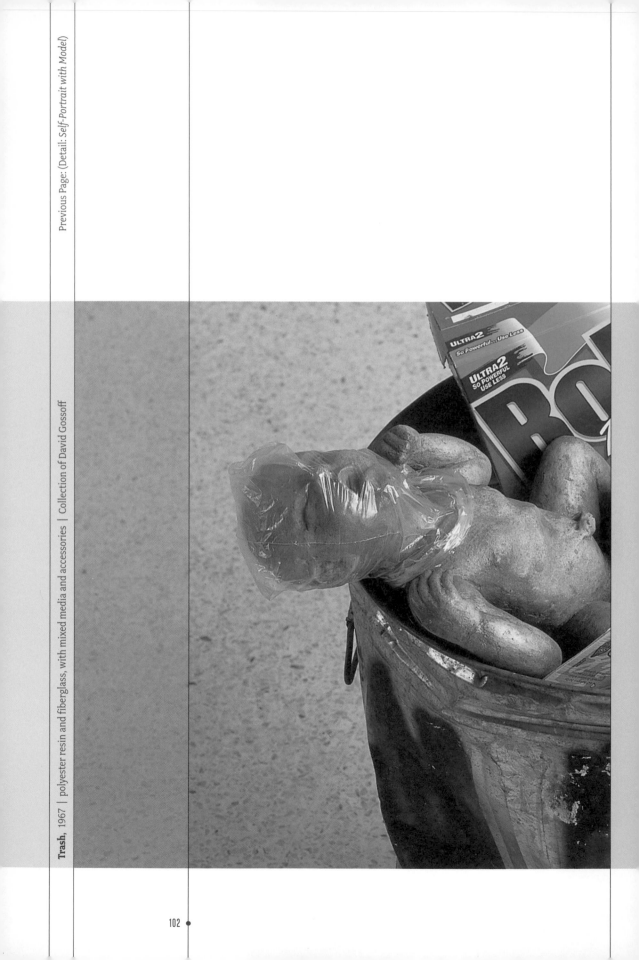

Trash, 1967 | polyester resin and fiberglass, with mixed media and accessories | Collection of David Gossoff

Trash *is the oldest work in the exhibition and one of Hanson's earliest works. It is also one of his most important for it established in his art his interest not only in societal issues of the day, but also an overall concern for humanity. From the early works, which were bold and explicit like* Trash, *Hanson would reformulate his expressions into more subtle presentations, never losing sight of his goal to recognize the everyman and woman and his or her plight. Consider, for example, the less shocking nature of* Chinese Student, *created in reaction to the massacre at Tiananmen Square in 1989.*

Trash *coldly presents the suffocated body of an infant child who lies lifeless atop garbage in a trashcan. With this horrifying scene, Hanson makes a powerful socio-political statement about the value of life. The viewer is confronted with the question: How is it possible that someone could throw away a human life in the same way one throws away an empty egg carton? Hanson created social realist works like* Trash *in order to bring such issues to the attention of the public, hoping that a dialogue—which began with the sculpture—would continue into public discourse.*

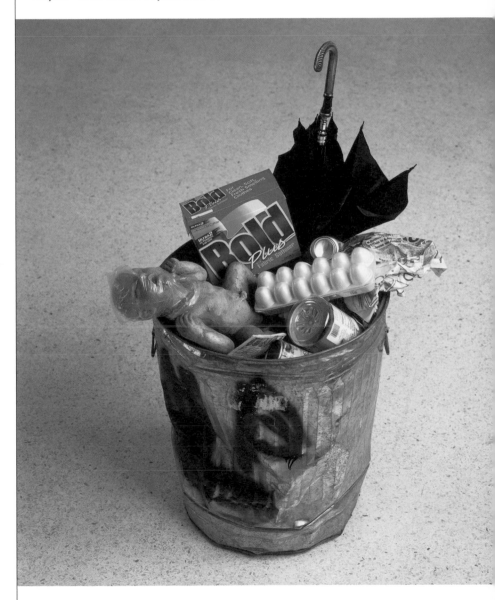

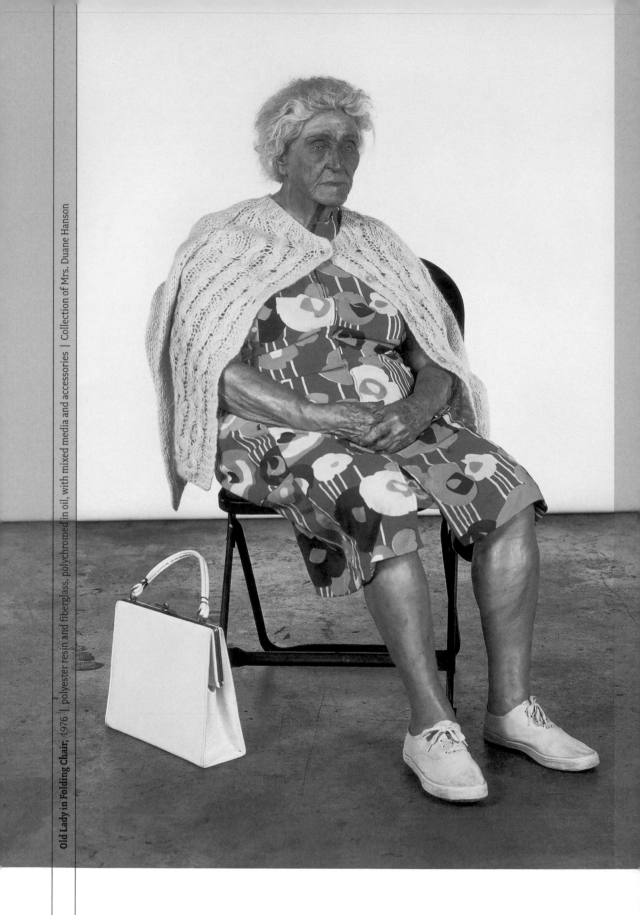

Old Lady in Folding Chair, 1976 | polyester resin and fiberglass, polychromed in oil, with mixed media and accessories | Collection of Mrs. Duane Hanson

Growing up in a Minnesota farming community during the Depression, Hanson was well aware of the intense labor required for an agrarian lifestyle as well as the financial hardships of the time. Hanson felt compassion toward the aged, recognizing their worn features as hard-won evidence of a difficult life. In this sculpture, he conveys world-weariness in the creased lines of the woman's face. The gravity of her expression is emphasized by her deeply furrowed brow. Hanson demonstrates his empathy for those whose years of hardship often remain unacknowledged by placing her in the museum setting, where she becomes the center of attention.

Children Playing Game, 1979 | polyvinyl, polychromed in oil, with mixed media and accessories | Collection of Mrs. Duane Hanson

The memories of childhood for Duane Hanson's children, Maja and Duane, Jr., are preserved not only in photographs, but also, and uniquely, in three-dimensional sculptures, giving them a sense of their former physical reality. Children Playing Game is an affectionate portrayal of the two children playing a game of Connect Four on a large Oriental rug. Their mood of innocence is, for Hanson, a respite from his more typically satirical or working-class portrayals.

Beagle in a Basket, 1988 | bronze, polychromed in oil, with mixed media and accessories | Edition 1/3 | Collection of Mrs. Duane Hanson

Man's best friend is forever preserved in the form of this affectionate and lifelike portrayal of the family dog. Beagle in a Basket is a tribute to the memory of the Hanson family pet, just as the sculptures of his children are tributes to the memory and innocence of childhood.

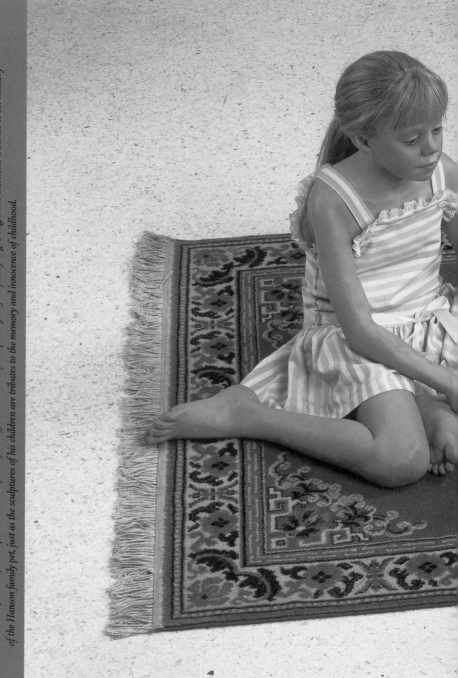

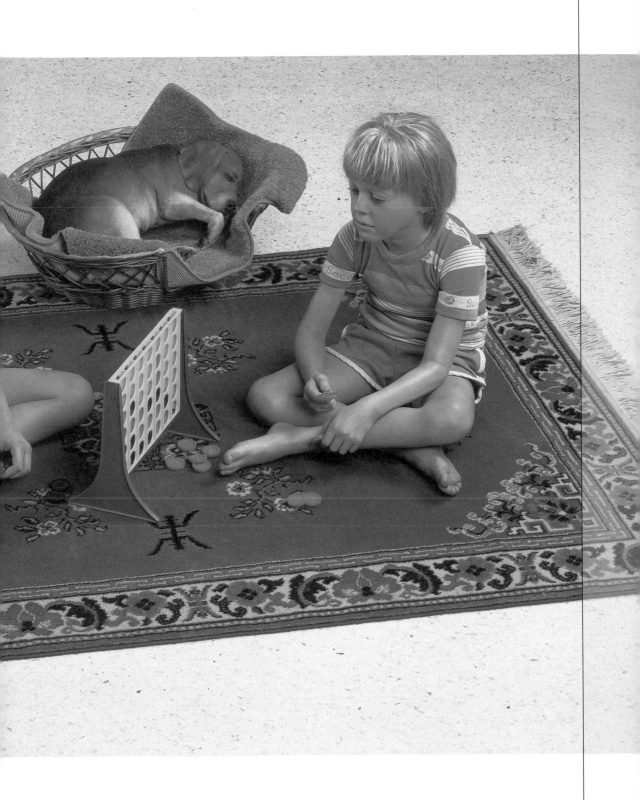

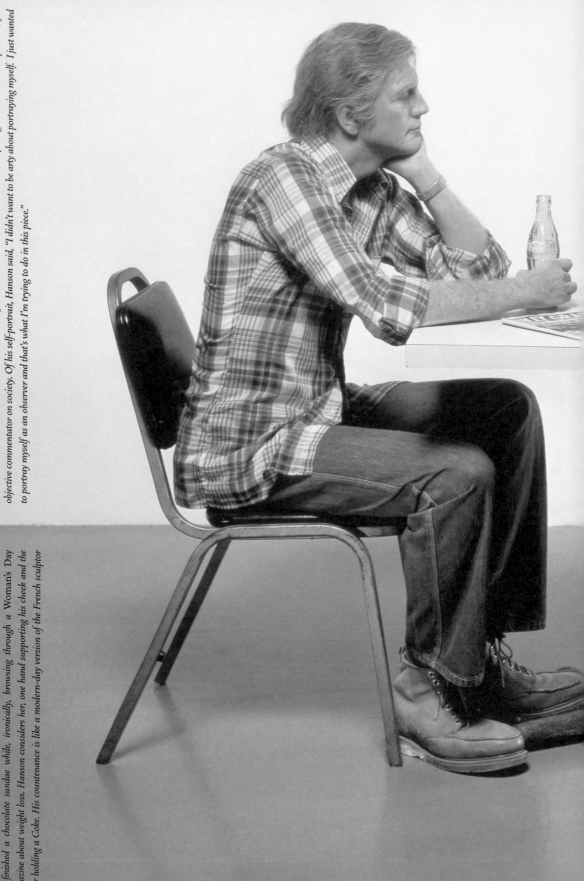

Auguste Rodin's introspective The Thinker. His gaze, however, is directed toward her, depicting his role as an empathetic, yet objective commentator on society. Of his self-portrait, Hanson said, "I didn't want to be arty about portraying myself. I just wanted to portray myself as an observer and that's what I'm trying to do in this piece."

Hanson portrays himself and a large woman, seated at a table in a diner. The woman has just finished a chocolate sundae while, ironically, browsing through a Woman's Day magazine about weight loss. Hanson considers her, one hand supporting his cheek and the other holding a Coke. His countenance is like a modern-day version of the French sculptor

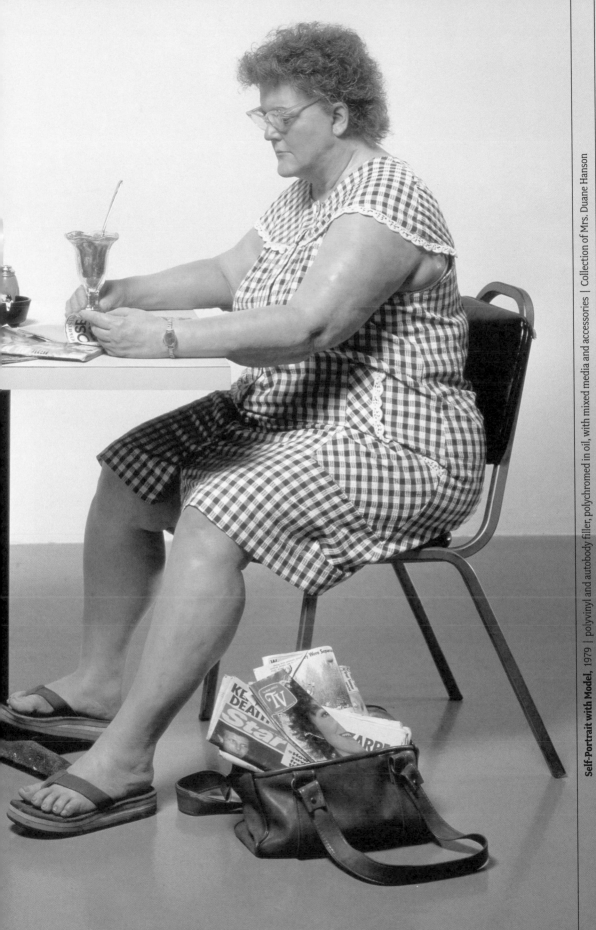

Self-Portrait with Model, 1979 | polyvinyl and autobody filler, polychromed in oil, with mixed media and accessories | Collection of Mrs. Duane Hanson

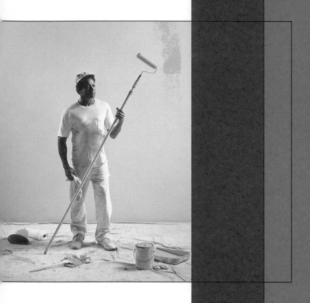

Housepainter, covered in paint from head to toe, appears to be taking a break from his work. He gazes ahead, absorbed in thought. We are drawn into his self-reflective space, which causes viewers to consider him, much as he ponders his own deep thoughts. Hanson often portrayed blue-collar workers in his sculptures, and although painting houses may be considered menial work, Hanson did not consider it as such. He recognized people for their hard labor occupations and immortalized them forever in his art.

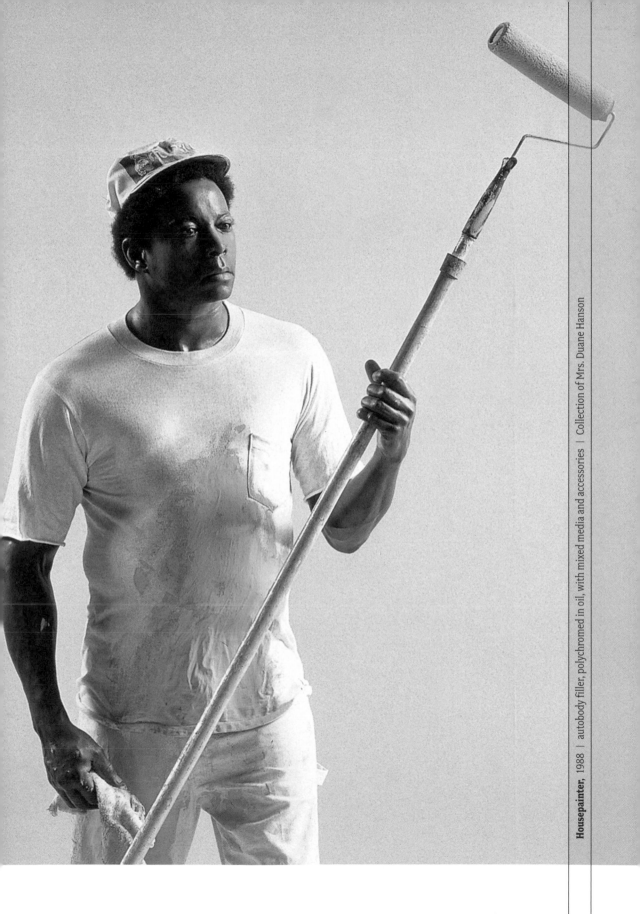

Housepainter, 1988 | autobody filler, polychromed in oil, with mixed media and accessories | Collection of Mrs. Duane Hanson

Queenie II, 1988 | autobody filler, polychromed in oil, with mixed media and accessories | Collection of Mrs. Duane Hanson

Queenie II, a depiction of a cleaning lady, was one of Hanson's favorite sculptures. He rarely used the actual names of his models when titling works, but he couldn't resist using the name of this particular model, which conjures images of grandeur and royalty. Although the general public might consider her work banal, Hanson presents her with the dignity and pride befitting a queen.

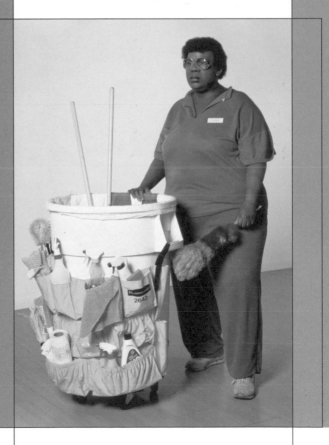

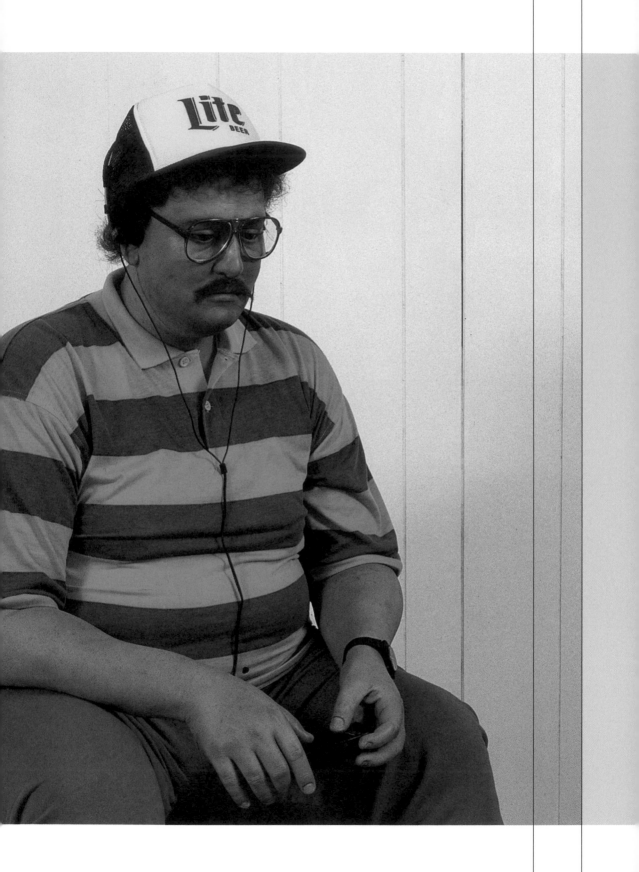

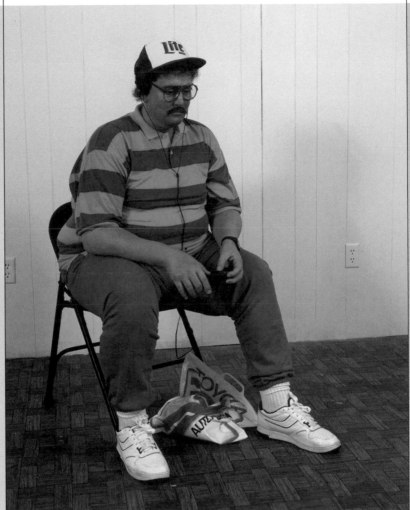

Man with Walkman, 1989 | autobody filler, polychromed in oil, with mixed media and accessories | Collection of Mrs. Duane Hanson

The satirical Man with Walkman *seems to have every intention of exercising—dressed in sweatpants, a pink-striped T-shirt, and holding a Walkman—yet sits on a chair with a look of complete exhaustion. His hat reads Lite beer and the bag at his feet advertises the vehicle manufacturing company Toyota, both examples of the irony Hanson wished to portray. We assume that the man is overweight due to a lack of exercise and excessive eating and drinking. Hanson points to the reality of consumer culture, which has replaced the need for exercise with products that promise to make up for that loss. This is an idea Hanson also explored in* Self-Portrait with Model *(1979).*

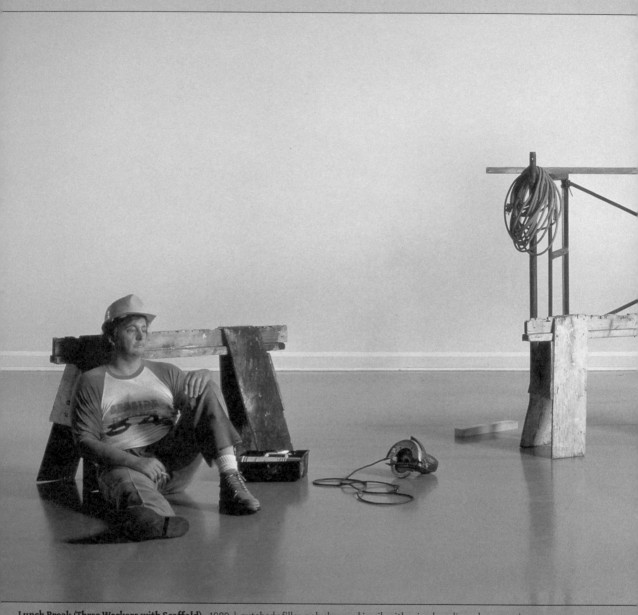

Lunch Break (Three Workers with Scaffold), 1989 | autobody filler, polychromed in oil, with mixed media and accessories

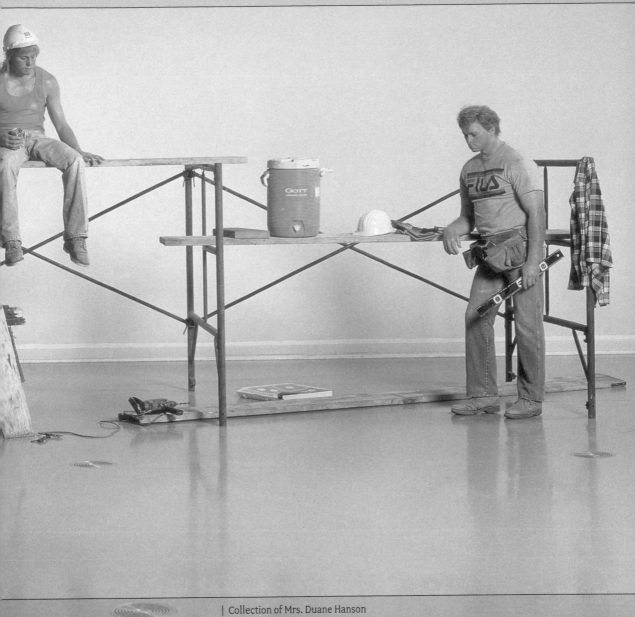

| Collection of Mrs. Duane Hanson

In Lunch Break, Hanson included real scaffolding and workmen's tools to enhance the physical environment of the sculptures. Three laborers appear exhausted from their work: one sits with his lunchbox open, having a smoke; another holds a level in hand, his arm supporting a tired body; and a third man, drenched in sweat, dangles his legs from the scaffolding while drinking a Coke. Their clothes are sodden, hair disheveled, and the skin of their arms and face is freckled and sunburned. The larger tableau of Lunch Break created an environment that viewers could potentially walk into, instead of merely around, thus becoming a part of the art themselves.

Chinese Student recalls the bloody and violent event that took place in Beijing's Tiananmen Square in 1989, when students protesting the Communist regime were gunned down by Chinese authorities. Hanson was deeply moved by this tragedy. The model Hanson used for this sculpture was Tin Ly, one of his longest serving assistants. The characters on the student's headband read "Fasting for democracy." The sign, made by Ly himself, reads "Victory to democracy." Chinese Student is similar to Hanson's earlier socio-political pieces, such as War (1967), Trash (1967), and Race Riot (1968), in which he addressed the social issues of war, civil, and human rights. Chinese Student, although emotional, reflects the less shocking approach Hanson adopted for his later works.

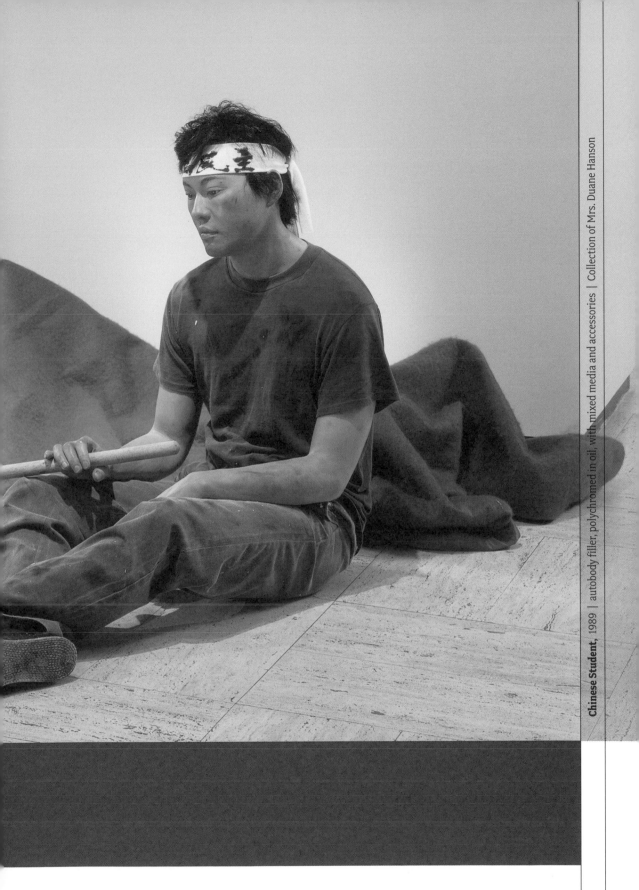

Chinese Student, 1989 | autobody filler, polychromed in oil, with mixed media and accessories | Collection of Mrs. Duane Hanson

High School Student, 1990 | autobody filler, polychromed in oil, with mixed media and accessories | Collection of Mrs. Duane Hanson

We're often asked what it was like growing up with these unforgettably realistic works all around. "Wasn't it eerie?" is a typical question. Well to us it was quite normal. Most people don't realize that the models were most often part of Dad's circle of friends and family. People were always happy and flattered to be immortalized in one of his works—our next-door neighbors, cousins, friends, and even the family dog were all his models.

We were cast three times each during Dad's career. For us it was fun and we tried not to give him too much grief. Slathering on Vaseline and having the hair on our legs ripped out are some of the more unpleasant recollections. But, we took it in stride and always wanted to know when we could model again. We posed for endless Polaroids—his version of a working sketch— and authenticated the works as much as possible by donating our own clothes: a high school cheerleading uniform (Cheerleader, 1988), bathing suit, and surfboard (Surfer, 1987). His assistant for many years, Tin Ly, posed for Chinese Student, 1989, and another long-time assistant, Scott Reed, posed for Lunch Break, 1989. Dad mentored many of his assistants, all aspiring artists who helped him with the casting process and of whom many are still family friends.

The bodycasting was a technique using silicone rubber with plastic outer mold and was usually done over several days. Models were clothed in undergarments, often shaving their arms and legs and then greased thoroughly with Vaseline. It was quite a challenge to diligently hold the perfect position for so long. The molds were later filled with liquid vinyl or Bondo (autobody putty) and then re-created over the course of months until perfected. Often times, the individual molds themselves were dramatically altered over this period.

Amongst a near tropical rain forest of blossoming orange trees, gardenias, and banana trees in the western-themed town of Davie, Florida, Dad enjoyed the lush surroundings. He kept peacocks, wild turkeys, and golden pheasants, most of the time allowing them to roam freely. He often entertained students, curators, and collectors from all over the world and even gave art lessons to our grandparents (his father and our mom's mother) and their friends. All were in their eighties and met for weekly Sunday lessons painting acrylic landscapes and portraits. A true night owl, Dad often worked well after midnight, breaking to indulge in his love of the classics, perhaps a Wagner opera.

He was also very active in the local art scene, often hosting large tour buses from local universities and art groups. They would bring their paintings to his studio for a critique. He was endlessly patient and quite constructive with his comments, and they really enjoyed it.

Dad considered himself a traditionalist, a classically trained sculptor whose re-creations of the body were inspired by his great interest in classical art of the past. It was a combination of tradition and close connection to the political currents of our modern era that made the work so unique, then and now. It is ironic, yet not surprising, that the work (which cannot be placed firmly into any of the artistic movements of the time—Pop, Minimalism, Abstract Expressionism), has inspired so many artists of today.

Maja Hanson & Duane Hanson, Jr.

From the exhibition catalog Duane Hanson; Selected Works 1984-1995, (O'Hara Gallery, New York, 2003), n.p.

Hanson offers a joke to the art world with this quirky installation. Surrounding the woman with bric-a-brac and tacky artwork, Hanson slyly comments on the value of literature and art in our culture. He points to the idea that literature and art, significant aspects of culture, have been degraded for the pursuit of profit. Ironically, this piece also focuses on the mediocre art objects within the museum context, typically reserved for "high art." Hanson once said, "...Wouldn't it be wonderful if someday this goes into a very fancy, snobbish museum or gallery. I sort of thumb my nose at so-called high art." With Flea Market Lady, Hanson ridicules the esoteric, self-important concept of "high art."

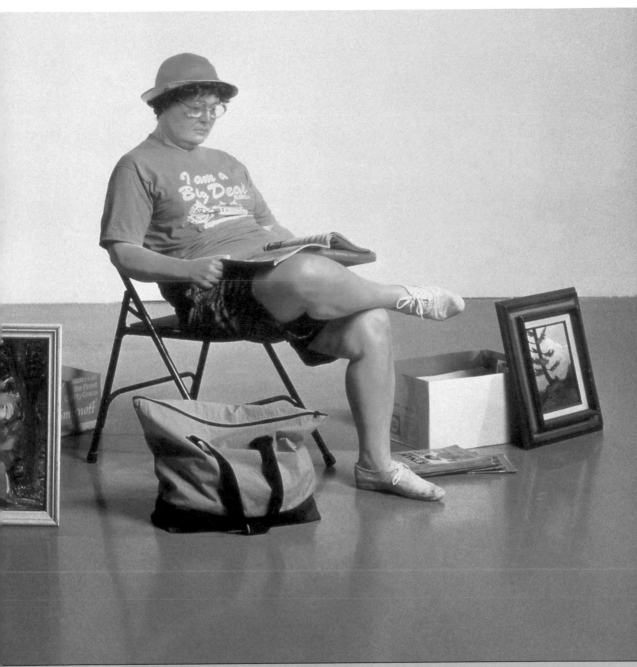

Flea Market Lady, 1990-1991 | autobody filler, polychromed in oil, with mixed media and accessories | Collection of Mrs. Duane Hanson

In his 1993 lecture to the National Art Education Association Convention in Reston, Virginia, Hanson said, "I always liked the idea about people holding a camera or taking a picture, because they are so contemporary in concept." The man, apparently on vacation, appears ready to take a photograph. A sober expression on his face makes us wonder what he is thinking. Is he enjoying what he is seeing or is he so concerned with getting an image on film that he misses the actual experience? Hanson was obsessed with the everyday man doing everyday activities. He noted, "Artists like Andy Warhol [. . .] have made us aware of those things around us which we never considered as art before. Pop Art is very important to me because it made not only realism legitimate again but got me to look very close to what we have."

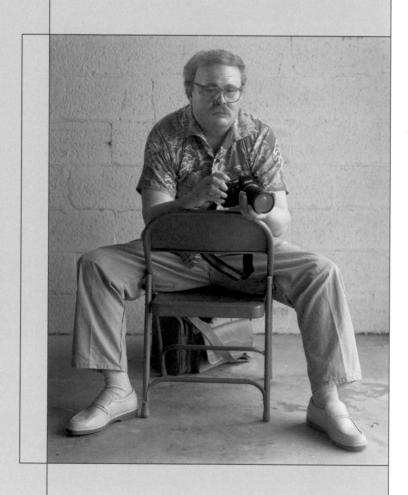

Man With Camera, 1991 | autobody filler, polychromed in oil, with mixed media and accessories | Collection of Mrs. Duane Hanson

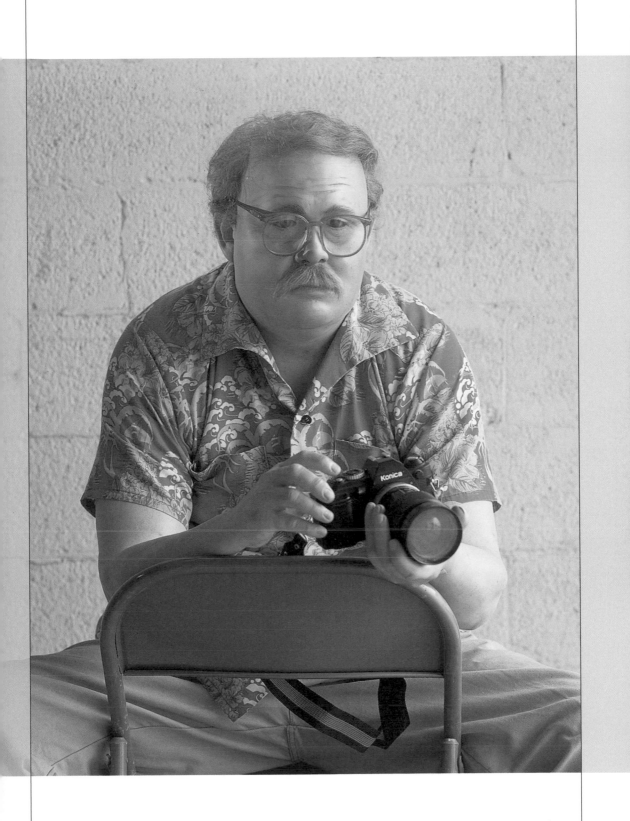

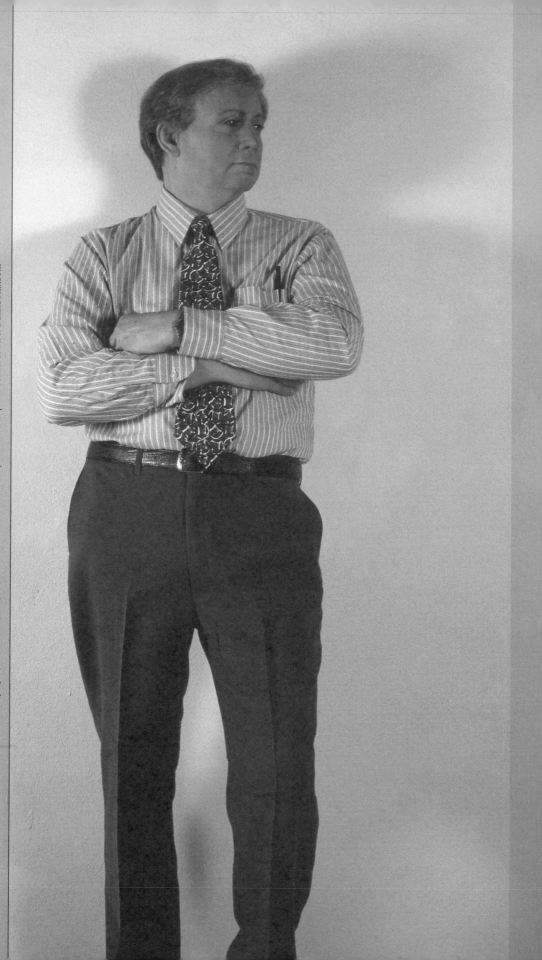

At first glance, this sculpture appears to be an average, middle-aged man, standing with his arms folded and gazing off to one side. However, the sculpture's title Car Dealer, brings to mind certain stereotypes about his profession as a salesman. Hanson cleverly brings to light with his simple, but deft application of the mere title—Car Dealer— the evocation of a certain type of occupation. But Hanson's portrayal, and the absence of props, reminds the viewer to look beyond the occupation's stereotype, and consider the man for what he is: simply a man.

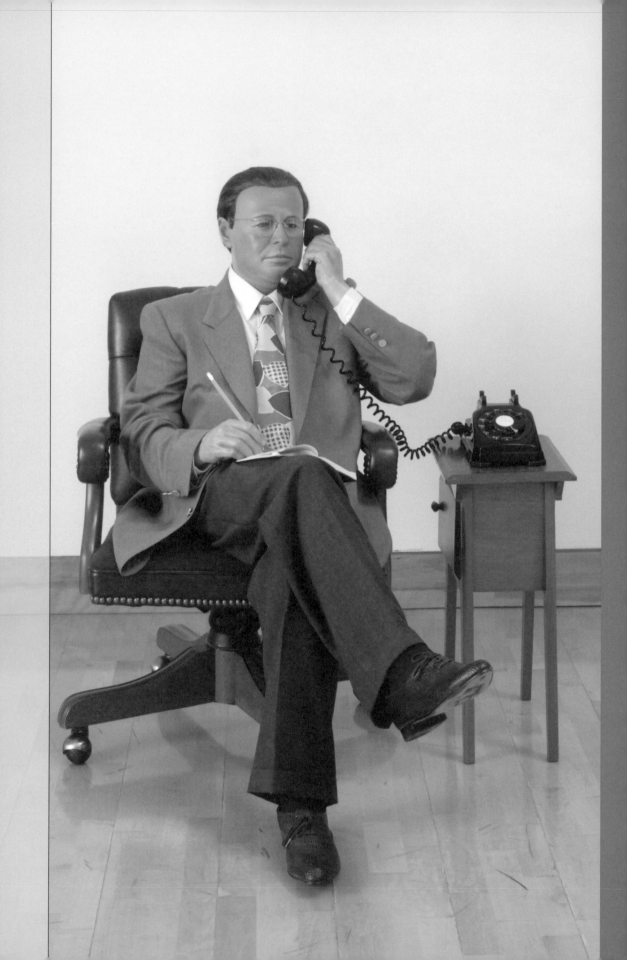

Executive in Red Chair, (Portrait of William Weisman) 1988 | bronze, polychromed in oil, with mixed media and accessories | Edition 3/3 | Collection of the Frederick R. Weisman Art Museum, University of Minnesota, Minneapolis

Hanson was commissioned to sculpt Minnesotans Mary Weisman and her husband, William, Executive in Red Chair, both important and affluent members of the Minneapolis/St. Paul community. (–continued next page)

Mary Weisman (Mother of Frederick R. Weisman), 1993 | bronze, polychromed in oil, with mixed media and accessories | Edition 1/3 |
Collection of the Frederick R. Weisman Art Museum, University of Minnesota, Minneapolis

(—continued from previous page)
The Weisman family, with a long-standing tradition of philanthropic support for the arts, played an important part in the establishment of the University of Minnesota campus museum, the Frederick R. Weisman Art Museum, designed by world-renowned architect Frank Gehry. Just as he recognized the contributions and efforts of the janitor, the policeman, and the medical doctor, Hanson recognized the successful benefactor to the arts.

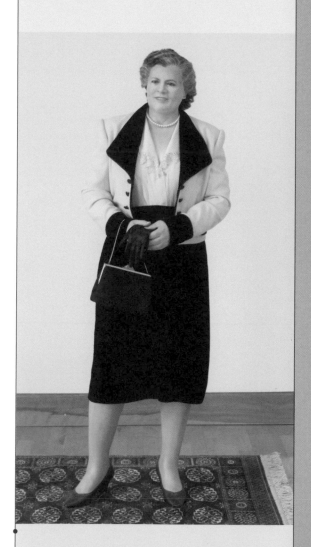

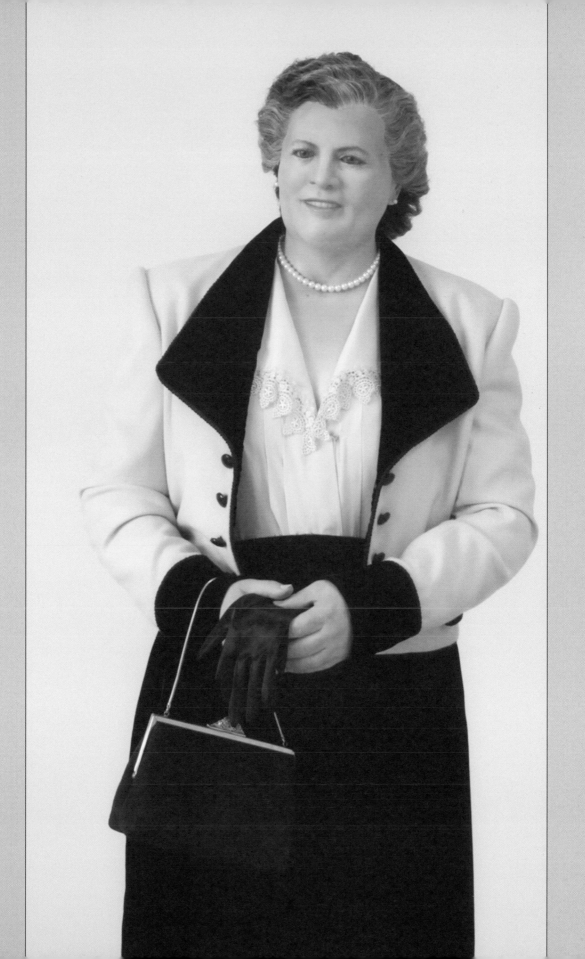

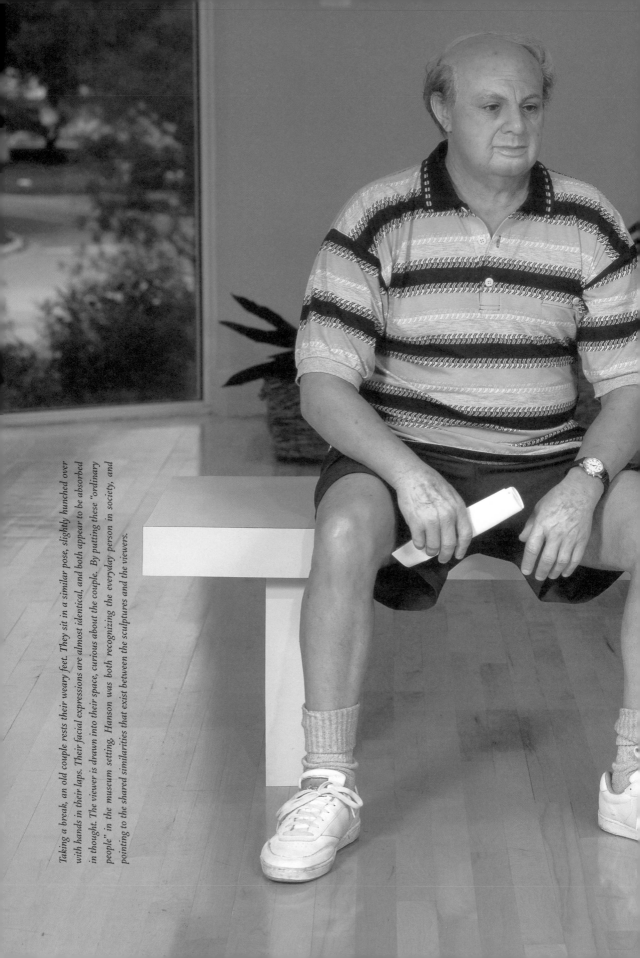

Taking a break, an old couple rests their weary feet. They sit in a similar pose, slightly hunched over with hands in their laps. Their facial expressions are almost identical, and both appear to be absorbed in thought. The viewer is drawn into their space, curious about the couple. By putting these "ordinary people" in the museum setting, Hanson was both recognizing the everyday person in society, and pointing to the shared similarities that exist between the sculptures and the viewers.

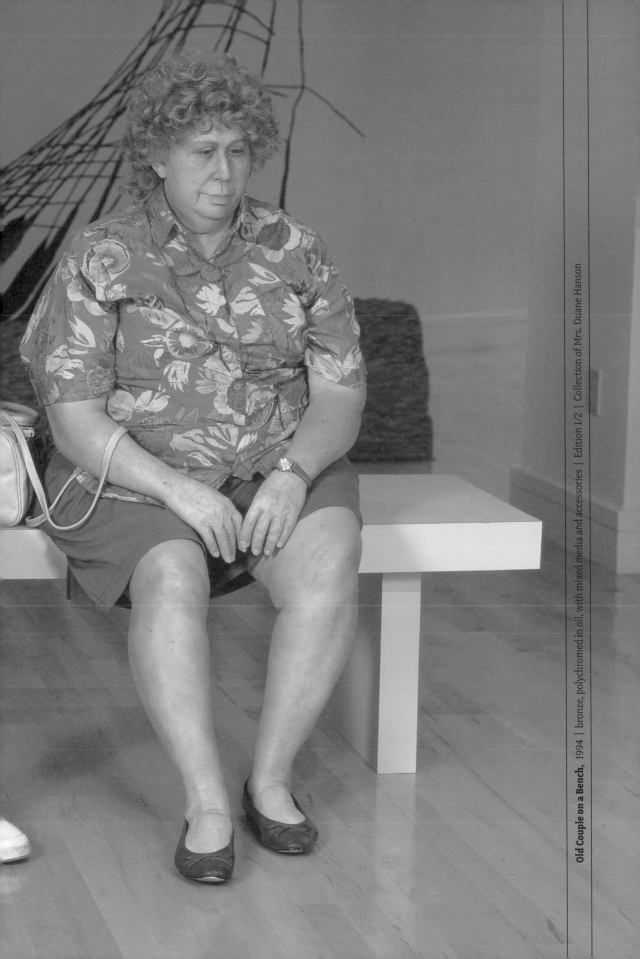

Old Couple on a Bench, 1994 | bronze, polychromed in oil, with mixed media and accessories | Edition 1/2 | Collection of Mrs. Duane Hanson

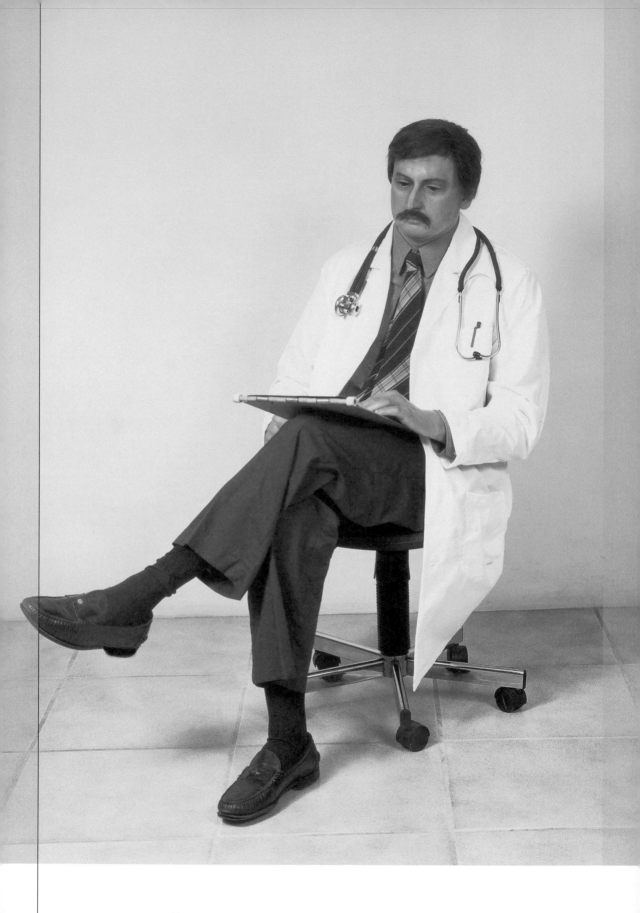

Hanson modeled Medical Doctor after one of his sons, Dr. Craig Hanson, a doctor in real life. Dressed in a typical white lab coat, stethoscope, and with a medical chart resting in his lap, the man appears concerned and somber. Must he convey a grave prognosis to a patient? Perhaps he is physically and mentally exhausted from the task of caring for other people. Although Hanson respected people in this profession and their dedication to healing the sick, he portrayed the doctor not as the heroic figure so often mythologized in today's world, but simply as a real-life individual.

Medical Doctor, 1994 | bronze, polychromed in oil, with mixed media and accessories | Edition 2/2 | Collection of Mrs. Duane Hanson

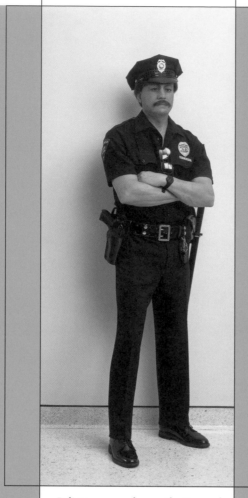

Policeman *exudes authority and control, dressed in uniform with arms crossed, wearing a nightstick and gun. However, in this sculpture, we also see another side of public authority. Temporarily caught off guard, the policeman is lost in thought, perhaps contemplating his occupation and the daily stress of safeguarding his fellow citizens. Hanson recognized the value of these members of society who daily risked their lives to protect the community. Paul Hanson, a policeman by profession and Hanson's son, was the model for this sculpture.*

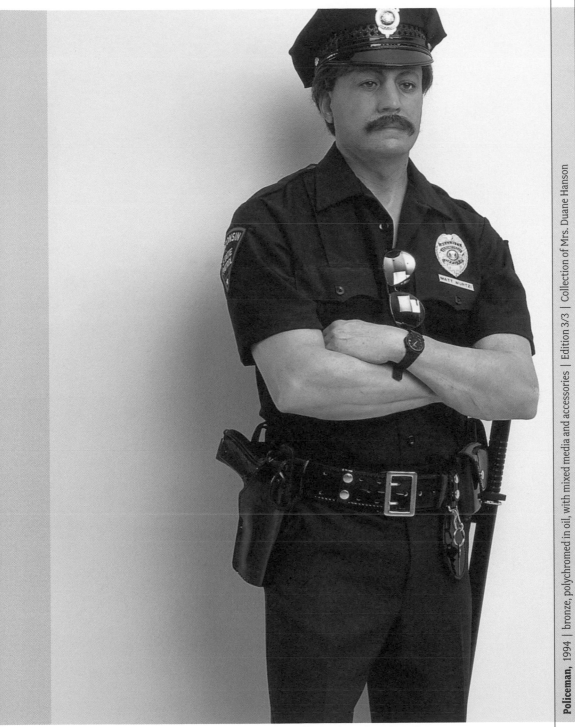

Policeman, 1994 | bronze, polychromed in oil, with mixed media and accessories | Edition 3/3 | Collection of Mrs. Duane Hanson

Bodybuilder, 1995 | autobody filler, polychromed in oil, with mixed media and accessories | Collection of Mrs. Duane Hanson

Hanson spoke about Bodybuilder in a 1993 lecture to the National Art Education Association Convention in Reston, Virginia, "...I like doing these sporty types and this one I wanted to show more flesh, more muscle." We rarely see Hanson's sculptures without their clothes, but here the viewer is able to scrutinize up close the artist's craftsmanship and modeling of human form.

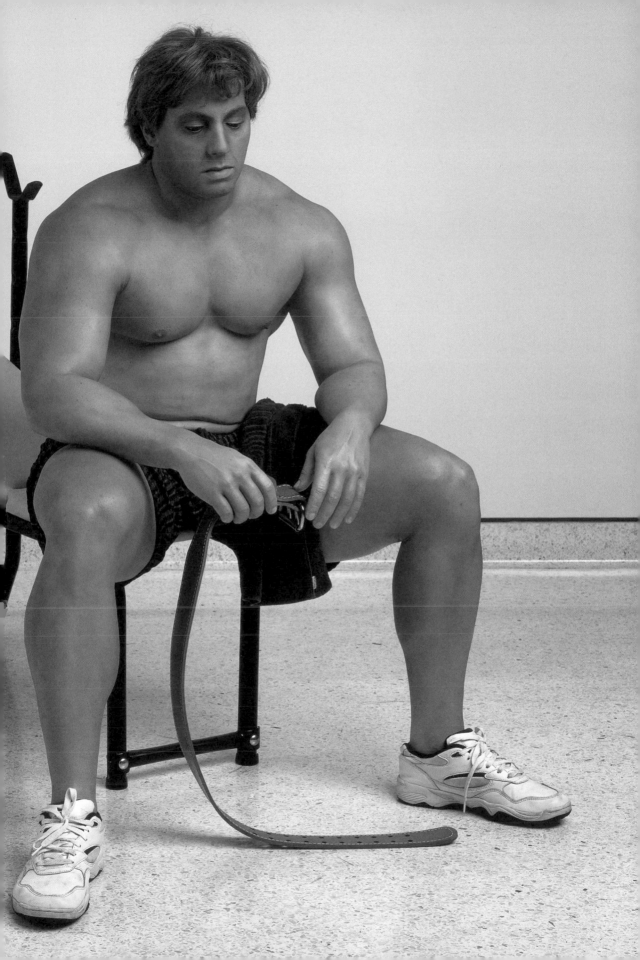

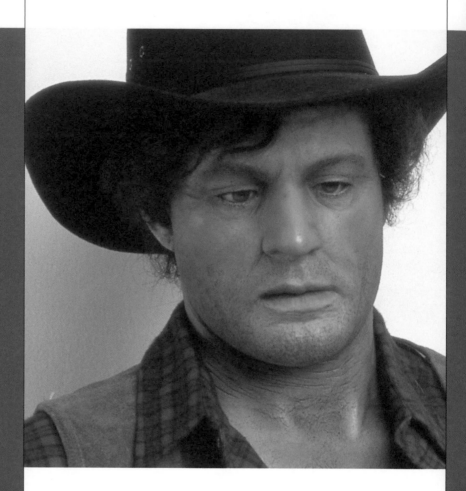

Hanson's portrayal of a modern-day cowboy has a rugged, tanned look. Dressed in typical Western regalia, complete with leather boots and a wide-brimmed Stetson, the cowboy leans casually against a wall, thumbs in his jean pockets. Hanson admired people like this cowboy, whose work was often strenuous and solitary. The cowboy is an iconic figure in America and a type very familiar to Hanson.

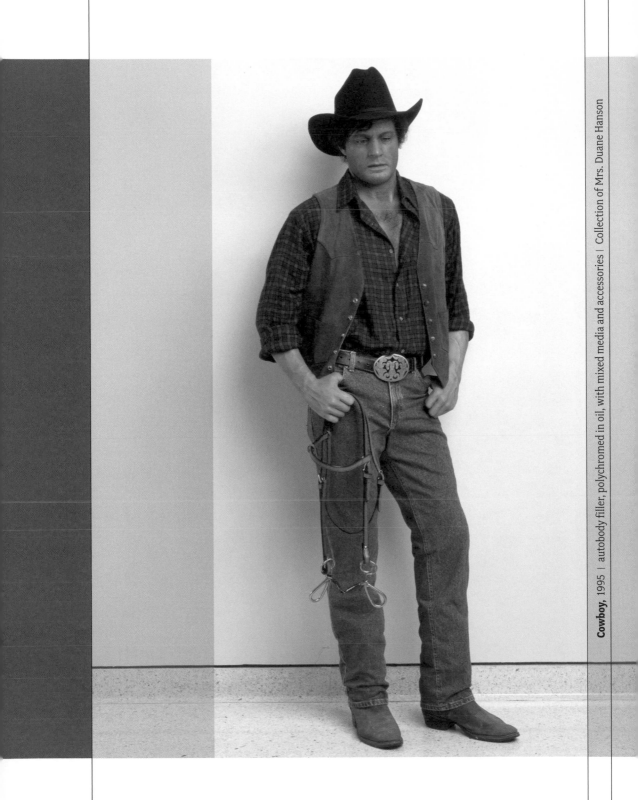

Cowboy, 1995 | autobody filler, polychromed in oil, with mixed media and accessories | Collection of Mrs. Duane Hanson

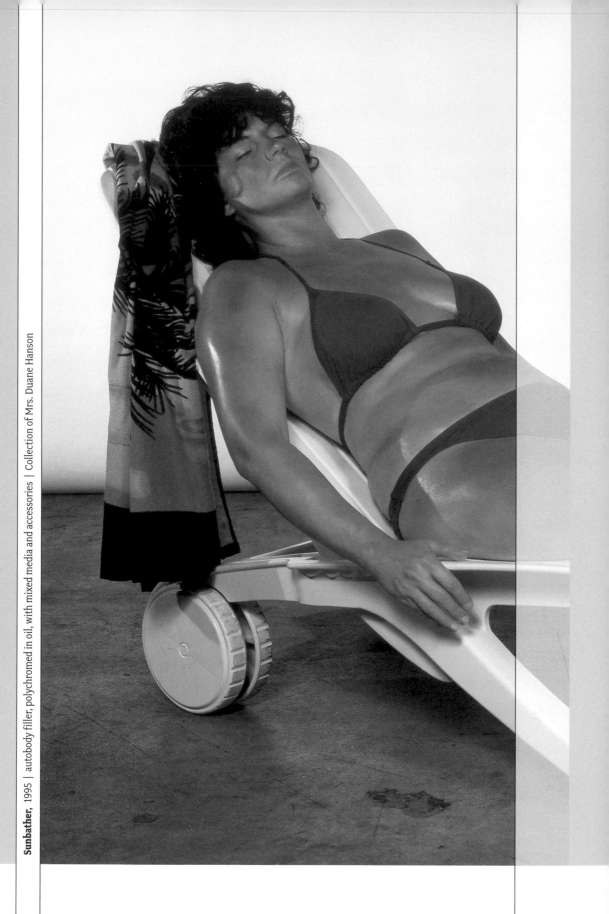

144

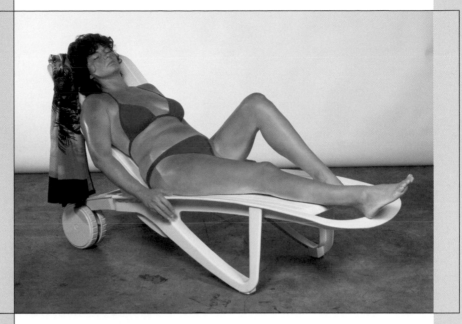

Hanson's first Sunbather was done in 1971, an obese and sunburned woman reclining on a lawn chair. The earlier depiction of Sunbather conveyed a simple irony: the woman desires the bronze skin of magazine models, yet ignores other aspects of her health. Later in his career, Hanson became more shrewd and selective in his presentation of subjects. In this 1995 version of Sunbather, Hanson presents a woman who appears ordinary. She is not a glamorous swimsuit model, nor is she the overweight, sunburned subject of the earlier sculpture. She is simply an average woman, the kind of person Hanson chose to herald throughout his career.

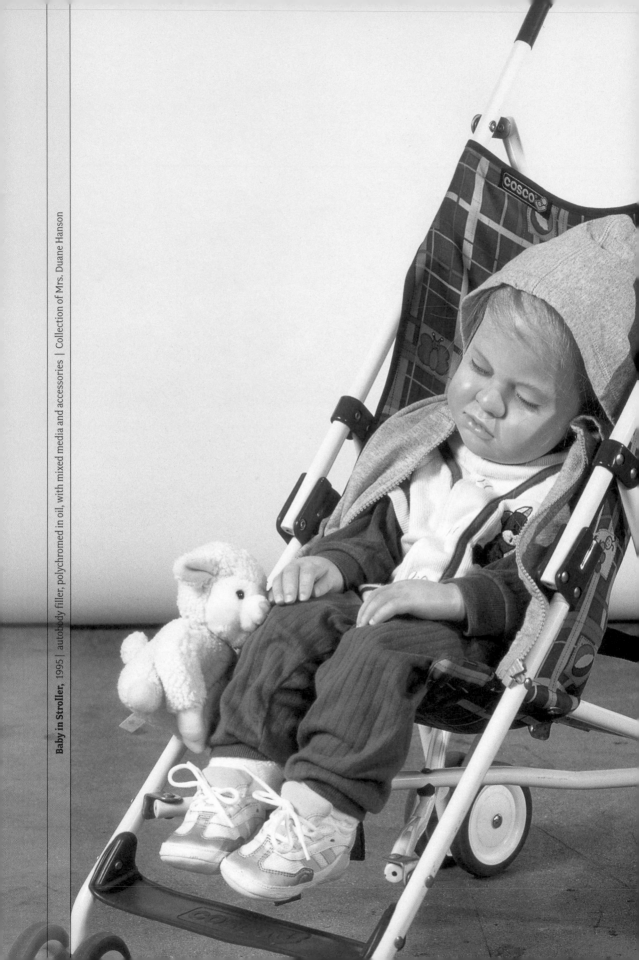

Baby in Stroller, 1995 | autobody filler, polychromed in oil, with mixed media and accessories | Collection of Mrs. Duane Hanson

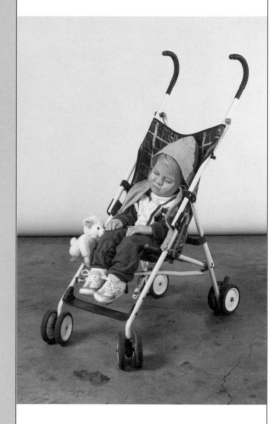

Hanson simply and realistically presents Baby in Stroller *as one might see the child in the real world: fast asleep in a stroller. Important to Hanson was the recognition and portrayal of a range of people, including a range between the old and the young. In the exhibition, the child shares the gallery space with sculptures like* Old Couple on a Bench *and* Old Lady in Folding Chair, *just as he or she would share and be a part of society in real life.*

Man on Mower, detail, 1995 | bronze, polychromed in oil, with accessories | Edition 2/3 | Collection of Mrs. Duane Hanson

Man on Mower *is one of the last sculptures Duane Hanson made and one of his most important. Hanson was always very interested in the everyday person, the regular guy who cuts his own grass. He considered these hard-working people overlooked, that they had not been given their full due. Hanson said this about the people he sculpted, "People, workers, the elderly, all these people I see with sympathy and affection. These are the people who have fought the battle of life and who now and then show the hard work and the frustration. The clothes they wear describe the life they lead. There is grubbiness and sweat, and there are old people with lines on their faces and the wrinkles. It's all about human activity, it's truth, and we all get there."*

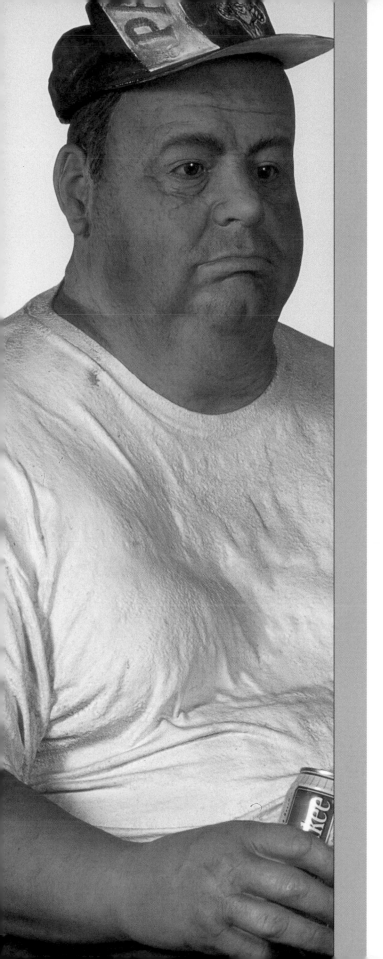

It was later in his career, with such works as Man on Mower, *that Hanson began using the medium of bronze, finding the material more durable than polyester resin. Because of bronze's permanence, he could consider installing his sculptures outdoors, as was intended with* Man on Mower. *Placing his sculptures in a new display context was a subtle shift in Hanson's artistic vision. He was, in a sense, testing his art by placing the sculpture in the real environment in which we live, instead of the white walls of the museum. This broadened scope would offer his sculptures a heightened realism and new considerations of meaning.*

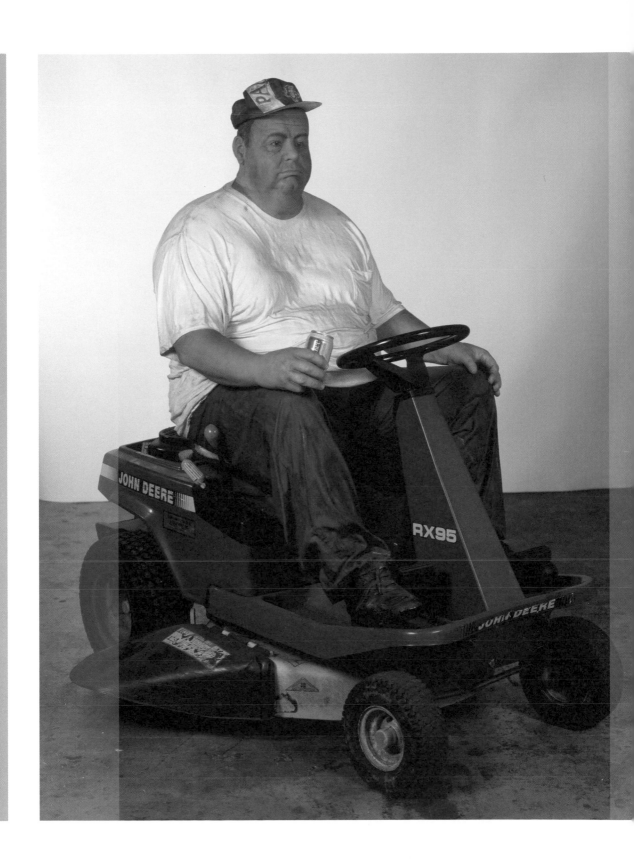

CATALOG ILLUSTRATION CREDITS

(front cover, back cover, inset; pg. 14; 16; 18; pg. 20, fig. 5; pg. 23, fig 6; pg. 24, figs. 7a, 7b; pg. 26; pg. 27, fig. 8; pg. 27, fig. 10; pg. 34, pg 36, fig 1; pg. 37, fig. 2; pg. 38, fig. 3, 5; pg. 39, fig. 4; pg. 40, fig. 6; pg. 41, fig. 7; pg. 42, fig, 8, 10; pg. 43, fig. 9; pg. 44, fig. 12; pg. 45, fig. 11; pg. 46, 47, fig. 13; pg. 48, fig. 14; pg. 49, fig. 15; pg. 50, fig. 16; pg. 51, fig. 17, 18; pg. 53; fig. 19; pg. 54, 55, fig. 20; pg 56, fig. 21; pg. 57, fig. 22, 23; pg. 58, fig. 24; pg. 59, fig. 25; pg. 60, fig. 26; pg. 61, fig. 27; pg.62, fig. 28; pg. 63, fig. 29, 30; pg. 64, fig. 31; pg. 65, fig. 32; pg. 66, fig. 33; pg. 67, fig. 34, 35; pg. 68, fig. 36; pg. 69, fig. 37; pg. 70, fig. 38, 39; pg. 71, fig. 40; pg. 72, fig. 41; pg. 73, fig. 42; pg. 74, fig. 43; pg. 75, fig. 44, 45; pg. 76, fig. 46; pg. 77, fig. 47, 48; pg. 78, fig. 49, 50; pg. 79, fig. 51; pg. 80, fig. 52; pg. 81, fig. 53; pg. 82, pg. 83, fig. 54, pg. 84, 88, 91, 96, 98, 99, 100, 102, 103, 104, 105, 106, 107, 108, 109, 110, 111, 112, 113, 114, 115, 116, 117, 118, 119, 120, 121, 123, 124, 125, 126, 127, 128, 129, 134, 135, 136, 138, 139, 140, 141, 142, 143, 144, 145, 146, 147, 148, 151, 160) Photographs courtesy of Mrs. Duane Hanson/© Estate of Duane Hanson/Licensed by VAGA, New York, NY.

(pg.18, pg. 21) Bruce Pettit, Photographer, courtesy Alexandria Chamber of Commerce.

(pg. 20. fig. 3) Sandra Ben-Heim, Photographer/©Estate of Duane Hanson/Licensed by VAGA, New York, NY.

(pg. 20, fig. 4) Photograph courtesy of Frieda Nowland, LaCross, WI/ Landsverk Family Photograph.

(pg. 27, fig 9) ©Faith Ringgold 1967.

(pg. 28, fig. 11) Milwaukee Art Museum, Gift of Friends of Art M1973.91/© Estate of Duane Hanson/Licensed by VAGA, New York, NY.

(pg. 28, fig. 12) Joslyn Art Museum, Omaha, Nebraska/©George and Helen Segal Foundation/Licensed by VAGA, New York, NY.

(pg. 28, fig. 13) George Hixson, Houston, Photographer, Courtesy of The Menil Collection, Houston/©Kienholz Estate.

(pg. 31, fig. 14) Denver Art Museum, Denver Art Museum Collection/©John DeAndrea: Funds from 1983 Collector's Choice, Linda and Charles Hamlin, Sheila Bisenius, Phyllis and Aron Katz, Jan and Frederick Mayer, Caroline and Rex Morgan, Gulf Oil, Marsha and Marvin Naiman, Joel S. Rosenblum Fund, and anonymous donors, 1984.1.

(pg. 84, 86/87, 95) Photographs courtesy of Tin Ly.

(pg. 130, 132, 133) The Frederick R. Weisman Art Museum at the University of Minnesota, Minneapolis, Gift of Frederick Weisman Company/©Estate of Duane Hanson/Licensed by VAGA, New York, NY.

CONTRIBUTORS

Erika Doss

Erika Doss is the director of the American Studies Program and professor of Art History at the University of Colorado, Boulder. Dr. Doss served as senior consulting editor and essayist for *The Encyclopedia of the Midwest* (Indiana University Press, 2003). She recently authored *Twentieth-Century American Art* (Oxford University Press, 2002). In 2000, she earned the "Exceptional Book of 1999" award from the Bookman Book Review Syndicate, for *Elvis Culture: Fans, Faith and Image* (University Press of Kansas, 1999). In 1992, Dr. Doss received the prestigious Charles C. Eldredge Prize for Distinguished Scholarship in American Art for *Benton, Pollock, and the Politics of Modernism: From Regionalism to Abstract Expressionism* (University of Chicago Press, 1991). Other books by Dr. Doss include *Spirit Poles and Flying Pigs: Public Art and Cultural Democracy in American Communities* (Smithsonian, 1995) and as editor, Looking at LIFE Magazine (Smithsonian Institution Press, 2001). Dr. Doss is also co-editor of the Culture America Series for the University Press of Kansas. Doss earned her doctorate from the University of Minnesota in Art History and American Studies.

Rusty Freeman

Rusty Freeman is the vice president for collections and public programs of the Plains Art Museum, and the curator and organizer of *Duane Hanson: Portraits from the Heartland.* He has organized solo exhibitions for artists Brad Tucker, Maria Friberg, Claire Corey, Kelly Nipper, Adam Chodzko, Paul Wong, and the exhibitions *The Walter Piehl, Jr. Retrospective* and *The Art of William Edmondson.* He has published essays in *Folk Art* magazine and Thieme-Becker Künstlerlexikon. Freeman received his Master of Arts in Modern and Contemporary Art History from the Virginia Commonwealth University in Richmond, Virginia. He makes his home in Fargo, North Dakota, with his wife, Rebecca.

Anna Goodin

Anna Goodin is the assistant curator of collections and exhibitions of the Plains Art Museum. Goodin assists with the coordination of exhibitions ranging from regional, national, and international artists and contemporary and historical exhibitions. Goodin received her Bachelor of Arts in 2001 from St. Olaf College in Northfield, Minnesota, with double majors in Art History and Music. She served an internship in the department of Indian and Himalayan Art at the Philadelphia Museum of Art in Philadelphia, Pennsylvania. Goodin plays the viola in the Fargo-Moorhead Symphony Orchestra.

Wesla Hanson, Maja Hanson, and Duane Hanson, Jr.

Wesla Hanson, wife of Duane Hanson, now lives in Davie, Florida, and manages the art works of her late husband. Daughter Maja, formerly a fashion designer, now teaches at Rhode Island School of Design in Providence, Rhode Island. Son Duane, Jr., a graduate of Brown University, resides in New York City where he works as information officer for an investment firm.

Tin Ly

Tin Ly has worked as a professional artist in South Florida for the past 24 years, and currently serves as a consultant for the Broward County Public Art and Design Program. He was twice awarded the Visual and Media Artist Fellowship from the South Florida Cultural Consortium in 1990 and 1999. Ly also twice garnered the Individual Artist Fellowship from the Florida Arts Council in 1986 and 1994. In 2000, Ly was the recipient of the Moretti Award for Artistic Achievement from the Cultural Foundation of Broward. Among his many public art commissions, he unveiled in 1999, to critical acclaim, *Communal Dream* at the Homeless Assistance Center in Ft. Lauderdale.

INDEX

Page references to illustrations appear in **boldface**. All artworks by Hanson, unless otherwise noted.